ON THE COVER: Cotton was king in Mesa in 1919, at the end of World War I, and to celebrate, the city held a cotton festival, the King Kotton Karnival. (Courtesy Arizona Museum of Natural History.)

IMAGES
of America
MESA

Lisa A. Anderson, Alice C. Jung,
Jared A. Smith, and Thomas H. Wilson

Copyright © 2008 by Lisa A. Anderson, Alice C. Jung, Jared A. Smith, and Thomas H. Wilson
ISBN 978-0-7385-4842-5

Published by Arcadia Publishing
Charleston SC, Chicago IL, Portsmouth NH, San Francisco CA

Printed in the United States of America

Library of Congress Catalog Card Number: 2007935840

For all general information contact Arcadia Publishing at:
Telephone 843-853-2070
Fax 843-853-0044
E-mail sales@arcadiapublishing.com
For customer service and orders:
Toll-Free 1-888-313-2665

Visit us on the Internet at www.arcadiapublishing.com

To all the pioneers of the Salt River Valley: Native Americans, Mexicans and Mexican Americans, Anglos, Asians, Arab Americans, African Americans, and others who have contributed so much to its rich history and vibrant cultures.

CONTENTS

Acknowledgments		6
Introduction		7
1.	The First Canal Builders and a New Desert Colony	11
2.	Creating a Community on the Mesa Top	19
3.	A Watershed Event	35
4.	From Frontier Town to Gem City	45
5.	World War I and Mesa	57
6.	Diversifying Mesa's Economy	65
7.	Mesa and the Great Depression	77
8.	World War II and Mesa	87
9.	The Boom Years	97
10.	Building on the Past to Create the Future	113

ACKNOWLEDGMENTS

This book is the result of a major collaboration between two cultural institutions, the Mesa Historical Museum and the Mesa Southwest Museum, now the Arizona Museum of Natural History. In 1999, a group of citizens began discussions about the most significant events in Mesa's history. In 2002, the city formally recognized 49 events as especially significant, and memorialized them on bronze plaques downtown. Keith Foster, curator of history at Mesa Southwest Museum, was an important figure in planning and implementing the Mesa Heritage Wall. When Keith retired from the museum three years later, he left the outline for a photographic exhibition based on the plaque project. Staff at Mesa Southwest Museum thought the subject warranted more substantive treatment and began planning a more ambitious, three-dimensional exhibition. Mesa Southwest Museum and Mesa Historical Museum were already exploring collaborations, and when the director of the historical museum, Lisa Anderson, heard of the project, she suggested a full partnership. The museums brought to bear the intellectual firepower of both institutions, and collections and photographs from both museums were used. The team considered hundreds of historic photographs for the exhibition, and more than 200 were included. *Searching for Mesa* opened in May 2006 at Mesa Southwest Museum, and it was installed in December 2006 as a long-term presentation of the history of Mesa at Mesa Historical Museum. Unless noted otherwise, the photographs featured in the book were gathered from this fruitful collaboration between the Mesa Historical Museum and the Mesa Southwest Museum.

Dr. Jerry Howard, curator of anthropology at Mesa Southwest Museum, was cocurator of *Searching for Mesa*. A noted specialist in Arizona prehistory, Dr. Howard was primarily responsible for the prehistoric sections, as well as those on the development of canal systems and the contributions of Dr. Chandler. Dr. Howard also has a broad knowledge of Mesa history, and his influence is evident throughout the project. Norma DeVoy, photograph archivist at Mesa Southwest Museum, provided valuable knowledge of both collections and history. Paula Liken, registrar, provided assistance with collections and photographs. The Mesa Southwest Museum exhibition team of Gene Letson, Carlos Hernandez, Tim Walters, and Michael Ramos installed *Searching for Mesa*. At Mesa Historical Museum, Carlos Hernandez, Keith Foster, and Doug Bancroft installed the exhibition, with assistance from Steve Hoza and Steve Ikeda. We thank them for contributions that were crucial to the success of the project.

INTRODUCTION

What image comes to mind when one thinks of the city of Mesa? Is it a frontier town in the Old West? An agricultural community based on cotton, citrus, and dairy? Or is it just a conservative Mormon town, a nice bedroom community, and a great place to raise a family? The Mesa we know today was all of these things at some point in its rich and complex past. History has seen Mesa grow from a tiny settlement in the desert into a city of almost half a million people, the 39th largest in the United States in 2007.

The first distinct prehistoric people to live in the Mesa area were the Hohokam, who flourished here for over 1,500 years. They were farmers and canal builders who lived throughout the valley in large villages of up to 500 people. The Hohokam are best known for their construction of a large network of irrigation canals. Construction on these canals began around 1 A.D. and continued until about 1450. The prehistoric canals were incredible works of labor and engineering. By 1450, the Hohokam canal system in the Phoenix area irrigated over 110,000 acres and was the largest irrigation system in the prehistoric New World.

The Hohokam irrigation system transformed the soils of the Salt River Valley, allowing them to grow abundant crops for both their own use and for trade. The Hohokam traded cotton cloth for seashells from the Gulf of California and for exotic birds from Yucatan. Eventually the Hohokam began to move from the area as they experienced a period of overpopulation, nutritional stress, and warfare. They disappeared from the area by around 1450, and there is no clear explanation of where they went.

Between the time of the decline of the Hohokam culture in the 15th century and the mid-1800s, no long-term settlements existed in the Mesa area. Intermittent conflicts between the Pimas and Maricopas along the Gila River and the Yavapais and the Apaches north and east of the Salt River Valley ensured the region would remain a "no-man's land" during that time. It was not until the establishment of Fort McDowell by the army in 1865 that permanent settlements, either Native American or Anglo, were created in the Salt River Valley. The effectiveness of the fort helped pave the way for Anglo settlements in Phoenix, Tempe, and Mesa. Just a year after the fort was built, Phoenix was settled, followed by Tempe in 1871.

Around 1870, many Pima, or *Onk Akimel O'Odham* (Salt River People), and Maricopa, or *Xalychidom Piipaash* (Upriver People), had left the Gila River and settled on the Salt River. In 1879, President Hayes established a new reservation for them that covered much of the Salt River Valley, closing large tracts of land to settlement. After protests from non–Native American residents, Hayes changed his mind, and on June 14, 1879, created a smaller reservation located just north of the future settlements of Lehi and Mesa. This reservation would be known as the Salt River Pima–Maricopa Indian Community.

The Pima, who believe they are the descendants of the Hohokam (a Pima word meaning "those who have gone"), and the Maricopa established a formidable military confederation to defend themselves from their common enemies, the Apaches and the Yavapai. They were farmers who could make the desert bloom, and early non-native travelers relied heavily on the crops they

produced. They served as trusted scouts for the U.S. Army and continue to serve their country today in various branches of the armed forces.

The first pioneers sent by Brigham Young arrived in the Mesa area in 1877. Intended originally to be "stations on the road" supporting the church's expansion into Mexico, according to Daniel Webster Jones's *Forty Years Among the Indians*, the settlers were attracted by the rich soil near the Salt River. Needing to bring water to the land so they could plant crops, "the Utah Company," as they were known, enlisted the help of the Pima and Maricopa living on the nearby reservation to clear the land and build canals. These pioneers created the settlement of Lehi.

The assistance of the Pima and Maricopa was critical in helping the little Mormon colony get on its feet. Tempe founder Charles Hayden loaned money and other resources to the Lehi group to pay for the services of their Native American neighbors. Company leader Daniel Webster Jones even traded some of the land claimed by the Lehi settlers to them in exchange for their labor. Formidable warriors with skills honed over centuries of bitter warfare with their Apache and Yavapai neighbors, the Pima/Maricopa discouraged Apache raiding parties with their mere presence.

The second group of Mormon settlers to arrive in the valley, the group that would become known as "the Mesa Company," reached Lehi in early 1878. This group established itself on the nearby mesa top and also began to clear the ancient canals to provide irrigation for their new fields.

Word reached church officials of the progress of the Mesa Company, and additional companies were soon on their way to the Salt River Valley. The next group of settlers arrived in the spring of 1878 and over the next few years others continued to make the journey to Mesa, bringing the town's population to a little over 300. Most of these groups settled within the original one-square-mile boundary of the new city. Nearly all of the main streets in downtown are named after them these pioneers.

Cultural diversity has been a part of Mesa's history from the earliest days of the settlement. The people who made up the companies of Mormon pioneers, white Europeans in terms of ethnic background, and the Native American people already living in the area were soon joined by other immigrants, including people of Chinese, Mexican, Japanese, Arab, and African American heritage. Some, such as the Japanese and Mexicans, came here to farm. Others, including the African Americans and Chinese, were lured here by the construction work available at the Roosevelt Dam site. Many Arab Americans were shopkeepers and peddlers in the mining towns of Arizona and made their way to Mesa, where they settled. All of these diverse groups of people have lived, worked, and contributed to the prosperity of Mesa.

Agriculture was the foundation of Mesa's economy from its founding until after World War II. The ideal combination of fertile, easily worked soil, plentiful irrigation water, and a year-round growing season produced consistently large crops of cotton, citrus, small grains, alfalfa, and vegetables. Dairy farming and stock-raising were an ever-increasing sector of the agricultural economy. Much of the workforce was employed in agriculture-related industries.

Surprisingly, agriculture was an important factor in attracting tourists to Mesa at the end of the 19th century and beginning of the 20th century. Canals, dams, and other irrigation-related projects brought visitors to the area. Early attractions included the nearby prehistoric ruins of the Hohokam, the beautiful desert scenery, Granite Reef Dam, fishing in the Salt River, and hunting in the desert.

In the years following World War II, the economy underwent a major transformation. Many factors were at work, including the mechanization of farming, the availability of affordable air-conditioning units that made living year round in the desert comfortable, the advent of the cold war, and the rising popularity of the Old West. The economy began to change from agriculture to one based on the high-tech, tourism, and service industries.

Over the years the little town that began as a "station on the road" continued to thrive. The population doubled every decade except the 1920s, and the city soon far outgrew its original one-square-mile boundary. The road has not always been easy for the citizens of Mesa. The city has endured epidemics, two major economic depressions, and has sent its sons and daughters off to two World Wars. Extreme heat, floods, and droughts also tested the spirit of its people.

Unfortunately prejudice and racism have also impacted nearly all of Mesa's diverse communities to varying degrees over the years. African American residents probably felt the impact of this more than any other group. Limited as to where they could buy homes and where they could send their children to school, black Americans had to work hard for whatever basic rights they had. Until desegregation took place across the United States in the 1950s, many minority citizens found themselves segregated in parks, swimming pools, movie theatres, dance halls, restaurants, and just about anywhere else local residents might congregate for business, play, and social activities. Arizona was also the site of relocation camps for many Japanese citizens during World War II. Since the end of that war and the desegregation of the following decade, ethnic minorities have made great strides. Their stories—good, bad, and in-between—are as much a part of Mesa as any that might be told.

In May 1979, the city was named an All American City by the National Municipal League. Mesa was honored for its efforts to address community problems through cooperation among citizens, schools, civic groups, and local governments, including the Salt River Pima–Maricopa Indian Community.

Today the city of Mesa is a thriving desert community bounded on all sides by smaller neighboring towns. The only other city in Central Arizona that is larger is Phoenix, to which Mesa is often spoken of as a suburb. Even though a grid of streets and freeways now connects all of these cities, Mesa's history remains in many ways unique from the other towns of the Salt River Valley.

Mesa was among the first in the region to recognize the potential of baseball as a community asset. Countless Major League players came to Mesa over the years, rejuvenating in the mineral springs of the Buckhorn Baths and slugging home runs at Hohokam Park, the Cactus League home of the Chicago Cubs. Industry giants like Motorola, Boeing, General Motors, and Talley Industries have set up operations in Mesa, providing prestige, jobs, and a real boost for the city's economy. The establishment of a variety of museums and the construction of the Mesa Amphitheatre and the new Mesa Arts Center has boosted the cultural community of the city.

Mesa's commitment to quality education is reflected in the constant expansion and improvements of its school system. The steady growth and quality of education provided by the Mesa Community College and the satellite campus of Arizona State University in east Mesa provide opportunities for higher education locally.

Mesa is also the home of one of the largest commercial airports in the region behind Phoenix's Sky Harbor. Phoenix Mesa Airport, formerly Williams Gateway, was renamed to reflect its relationship with Phoenix's air hub. But the airfield affectionately known as "Willies" from its military years has a unique and important history and close ties to Mesa.

Without a doubt, Mesa will continue to grow and create an identity of its own in the Salt River Valley for years to come.

One
The First Canal Builders and a New Desert Colony

The origins of Mesa lie in the community of Lehi in the north central part of the city. The first Anglo pioneers, sent by Brigham Young, arrived in the Mesa area in 1877. This group, known as the "Utah Company," settled in the northern area eventually known as Lehi. The fertile soils of the area, on low land near the Salt River, attracted the settlers. Although the ground was rich, the settlers needed water to irrigate the land. The Utah Company enlisted the help of the *Akimel O'odham*, or Pima, to clear land, dig canals, and plant crops, saving them much time and effort.

The pioneers constructed a fort at the settlement to protect them from Apache and Yavapai raiders, a fear that was never realized. With in the walls of the fort, settlers pitched tents until they could build permanent homes. The layout of the town, first called "Utahville," consisted of a one-square-mile site built around a public square.

They were soon followed by the group of settlers known as the "Mesa Company," who joined the Utah Company in Lehi on February 14, 1878. The company decided to investigate whether water could be brought from the river onto the mesa top. They traced the outline of the historic channel known as "Montezuma's Canal" and other ancient canals from their source at the Salt River and became convinced water seemingly could be "moved uphill" by intersecting the river higher up. Work on the Mesa Canal began in 1878. Digging the canal out of the hard desert ground was a long and difficult task that took over nine months to complete. The first of the Mesa Company moved to the mesa top in October 1878.

The settlers of both Lehi and Mesa struggled to carve out a life in their new location. Life was hard for the Mormon pioneers. Settlers faced flood, food and supply shortages, isolation, intense summer heat, and epidemics. And although Mesa now had water, it was a constant struggle to maintain the canals, with breaks occurring constantly.

Other Mormon settlers continued to arrive in the area during the next decades. The little settlements began to grow and thrive.

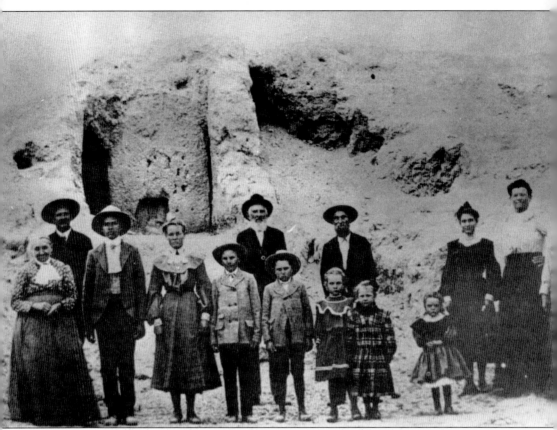

The Hohokam irrigation system transformed the soils of the Salt River Valley. Irrigation water carried nutrients and fine particles of soil that were deposited on the fields, increasing their fertility and ability to retain water. The Hohokam successfully raised abundant crops of beans, corn, squash, and cotton. Similar in many respects to the cultures of prehistoric Mexico, the Hohokam built ball courts where they played a ball game similar to those of the Aztecs. The Hohokam also constructed temple mounds resembling the pyramids in Mexico. One of the largest of these mounds, the Mesa Grande, is located only two miles from downtown Mesa. The Lewis family is standing in front of the ruins of Mesa Grande in this undated photograph.

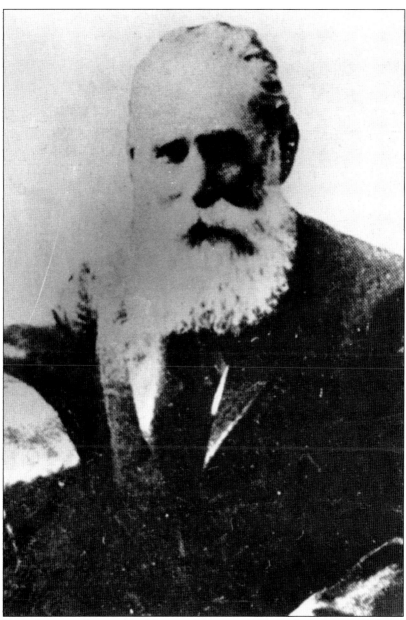

Daniel Webster Jones was born on the Missouri frontier in 1830. Orphaned at age 12, he volunteered to fight in the Mexican War in 1847. Jones stayed in Mexico for a few years following the war, learning Spanish and developing respect for Mexican and Native American peoples. He was baptized into the Mormon faith in 1852 and spent the next 25 years impressing his new churchmen with his heroic actions. He fought in what has been called the Mormon War of 1857, and acted on behalf of the Native Americans in Utah. Jones gained the trust of Brigham Young and was sent by him on a yearlong mission to Mexico in 1875. Upon his return, Jones was called by Young to colonize Arizona's Salt River Valley. After disagreements with his fellow settlers, mainly over his zeal in proselytizing to the Native Americans, Jones left the settlement of Lehi and moved to the Tonto Basin in the mid-1880s. He published his autobiography, *Forty Years Among the Indians*, in 1890. He died in Mesa in 1915.

A source of irrigation water had to be secured before crops could be planted. Work on the future Utah Ditch was begun as soon as the farmland was surveyed. The company had few earth scrapers, and their animals were exhausted from the long journey from Utah. Due to the urgency of getting the ditch completed in time for spring planting, the work was done by hand, using both Mormon settlers and hired Native Americans.

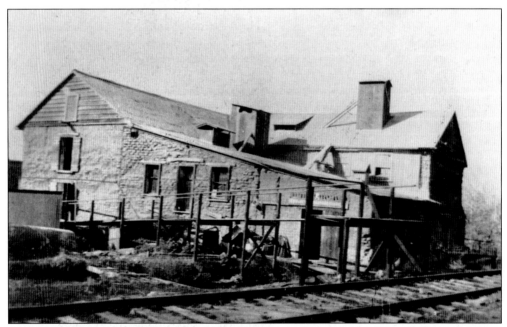

Charles Hayden of nearby Tempe stands out as a benefactor to the future Lehi community. Hayden assisted the pioneers in a variety of ways, loaning them funds and goods to pay the Native American workers on the ditch, as well as for other costs associated with the canal's construction. His help was invaluable to the survival of the young colony.

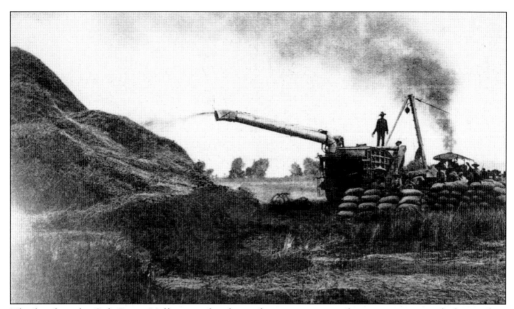

The land in the Salt River Valley was fertile, and once a source of water was secured, the settlers at Lehi were able to grow a wide variety of crops, including winter wheat, alfalfa, sorghum, corn, grapes, fruit trees, and vegetable gardens. Aside for personal use, much of the produce was sold to the army at nearby Fort McDowell and to mining camps.

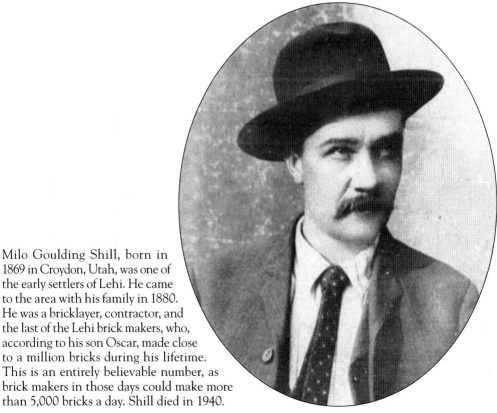

Milo Goulding Shill, born in 1869 in Croydon, Utah, was one of the early settlers of Lehi. He came to the area with his family in 1880. He was a bricklayer, contractor, and the last of the Lehi brick makers, who, according to his son Oscar, made close to a million bricks during his lifetime. This is an entirely believable number, as brick makers in those days could make more than 5,000 bricks a day. Shill died in 1940.

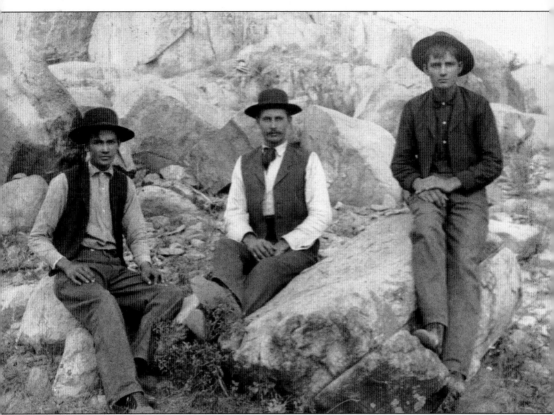

Wright, Victor, and Ralph Shill were the younger brothers of Milo Shill. Wright P. Shill, on the left, was born on January 12, 1880, in Croydon, Utah. He came to Lehi in the fall of 1880 with his family. Wright began keeping a journal of everyday life in Lehi and Mesa in 1894 at the age of 14. His journals, later oral histories, and history talks are the source of much firsthand information about the early years of the community. He also served as bishop of the Lehi Ward between 1908 and 1914. He lived until the late 1960s. Another brother, Victor, center, died in 1906 when a blast he and two others were preparing in a limestone quarry went off prematurely. Not as much is known about Ralph, right, except that he worked at his brother Milo's brickyard.

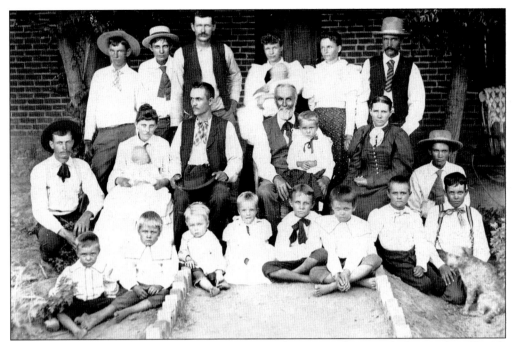

Members of the Shill and Biggs families pause for this group photograph during their Fourth of July celebration in 1897. These were some of the earliest families in the Lehi area. The Biggs family ran a store and post office there for many years. Milo Shill is at the top right, and his son Oscar is in the front row on the left.

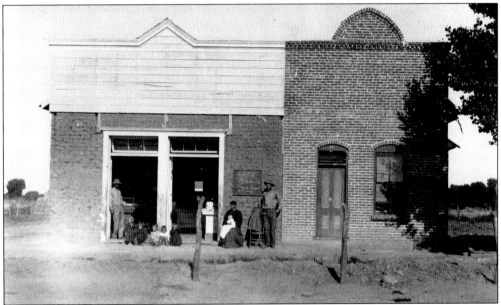

Members of the Biggs family opened a general merchandise store sometime around the mid-1880s. They ran their first store from their house, but by the late 1880s, had built a separate store near the center of Lehi. That store burned in 1892, putting it out of business temporarily. This photograph, showing members of the Biggs family, was taken around 1897. The Lehi Post Office was run out of this store for years.

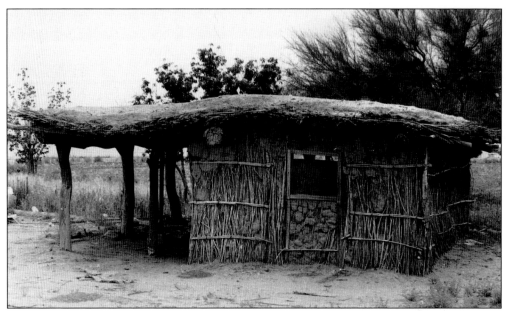

The Pima and Maricopa people had settled just north of what would later become Lehi around 1870. The construction of Fort McDowell in 1865 had made it safer to settle in the area. These peoples never became an integral part of the Lehi and Mesa settlements, preferring to live on the nearby reservation. This small house was typical of those on the reservation in the late 1800s.

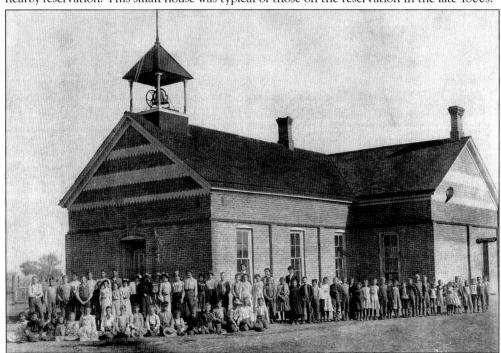

The Old Lehi School was originally built as a one-room adobe schoolhouse in 1881. Two rooms were added later, and the outside was veneered in brick. This photograph from 1904 shows the students and faculty posing outside the schoolhouse. The Mesa Historical Museum occupies the site today.

Two

Creating a Community on the Mesa Top

Word soon reached officials of the Mormon Church back in Utah of the progress of the Mesa Company. Additional groups of pioneers were soon on their way to the Salt River Valley. Over the next few years, the town's population grew to a little over 300 people. Most of these newcomers settled within the town's one-square-mile area of homesteads and businesses.

From the town's physical layout to the cooperative spirit of its residents, Mesa was ideally suited to prosper in a harsh desert climate. One of the city's unique features was the unusually wide streets, wide enough to turn a carriage around. These wide streets are still evident today throughout the original city.

Most of the citizens were involved in farming in one way or another. Many early businesses, such as mercantilism, blacksmithing, and livery, among others, supported the agricultural endeavors of the community.

To avoid the monotony of daily life, Mesa residents found leisure in reading, dancing, swimming, and visiting neighboring towns, as well as in watermelon feasts, picnics in the desert, saloons, and holiday celebrations. Education was a priority, so children attended school and helped out at home or in the fields while enjoying an occasional sweet treat or a game of hoops or marbles with friends.

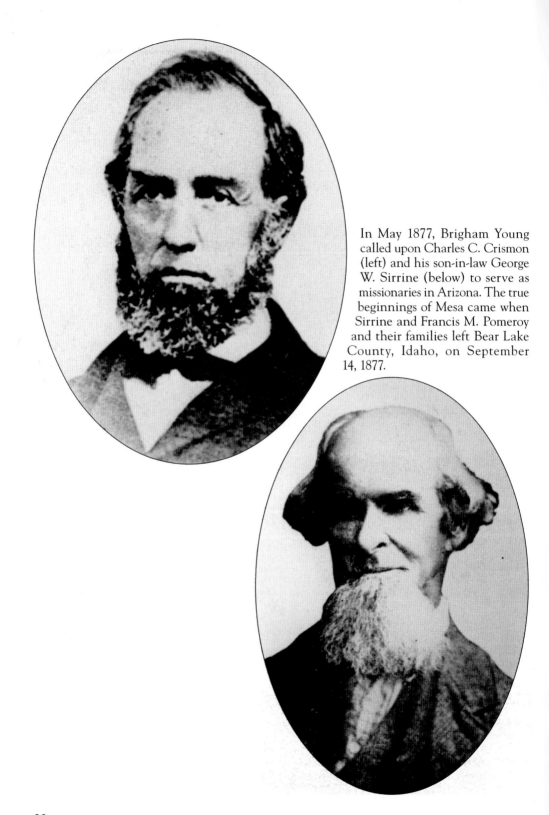

In May 1877, Brigham Young called upon Charles C. Crismon (left) and his son-in-law George W. Sirrine (below) to serve as missionaries in Arizona. The true beginnings of Mesa came when Sirrine and Francis M. Pomeroy and their families left Bear Lake County, Idaho, on September 14, 1877.

This group met up with the Crismon and C. I. Robson families in southern Utah. The group had slightly more than 80 pioneer missionaries, later known as the Mesa Company, who headed south and arrived at Fort Utah/Jonesville (Lehi) on February 14, 1878. Charles C. Crismon, George W. Sirrine, Francis M. Pomeroy (right), and C. I. Robson (below) are the four men known as "the Founding Fathers of Mesa."

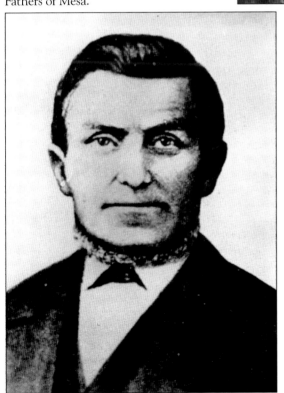

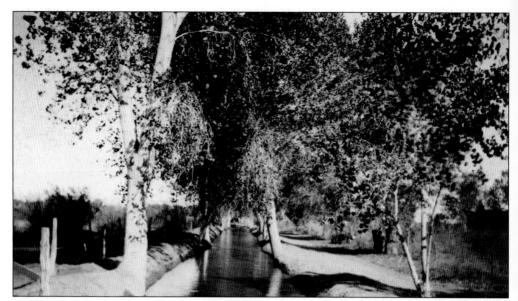

This tree-lined canal is an example of the early irrigation ditches in Mesa. The effort of the Mesa Company in digging the canal paid off for its individual members. Each man was allotted portions of land in the new town site, based upon the amount of work each had contributed toward digging the canal. Shares in the canal were valued at $200 each, and town site lots at $50.

This is a view of a neighborhood in early Mesa. The lots were large and contained houses of adobe or brick. Most of the homes had gardens and small orchards of fruit trees irrigated by the canals. Families often slept out amongst the trees during the heat of the summer. They would hang wet sheets in the trees, and the breeze would help cool them off enough to sleep.

As the Mesa Canal was being completed, the settlers were clearing their own land, cutting through desert brush in preparation for farming. Some of the first homes built on new lots were constructed of cactus posts, adobe, and had dirt floors. Adobe homes, such as this one, were common until the 1890s.

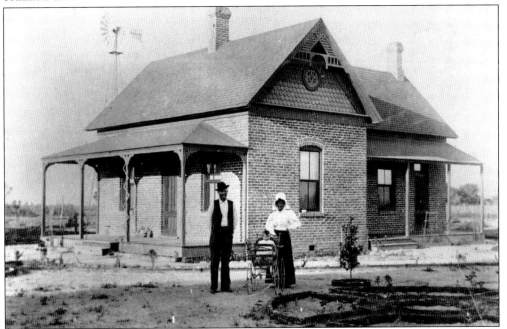

Brickyards in Lehi supplied most of the materials used in the early brick- and wood-framed houses. Lumber had to be freighted in by horse and wagon until the railroad arrived in Mesa in 1895. A few brick homes of the 1890s era still exist today in Lehi and Mesa, including the Biggs home and the Sirrine House.

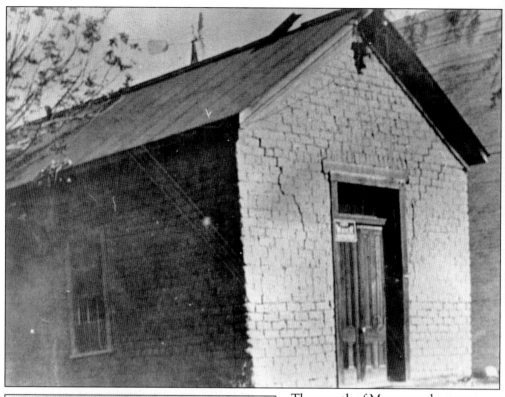

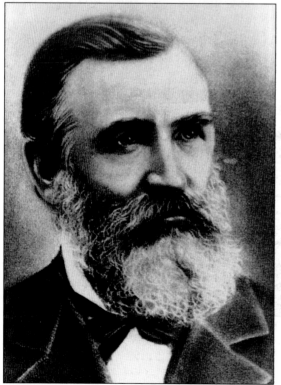

The growth of Mesa over the next few years was slow but steady. In 1883, when the population passed 300 people living at the town site, Alexander Findlay Macdonald petitioned the county government to establish a local government. The town was incorporated on July 15, 1883. Twenty-nine Mesa residents voted in the first election, choosing Macdonald as the first mayor. This small adobe building was the first city hall.

Alexander Findlay Macdonald was born in Scotland in 1825 and arrived in Mesa with his family in 1880. He was a successful businessman and the first president of the Maricopa Stake. Macdonald was called to Mexico by the Latter-day Saints (LDS) church in 1887, where he served as scout, explorer, goodwill ambassador, and purchasing agent for the church in its effort to establish colonies in Mexico. He died in Mexico in 1903.

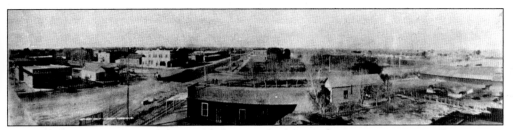

Mesa's Main Street supported the establishment of a thriving business community. Occupations that supported the community in the late 1800s included doctors, butchers, saloon keepers, teachers, carpenters, barbers, livery stables keepers, and dressmakers. The wide streets are visible in the picture.

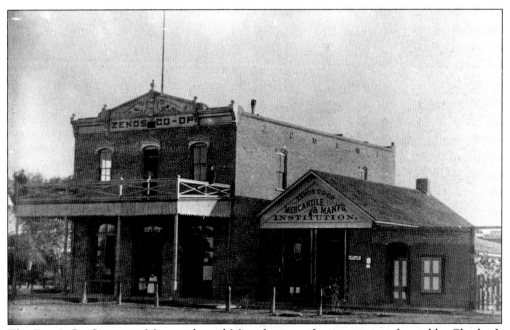

The Zeno's Co-Operative Mercantile and Manufacturing Institution was formed by Charles I. Robson, George Passey, and Oscar M. Stewart in 1884. The store, built later that year just west of the southwest corner of Main and Macdonald Streets, was the most important building on Main Street at the time. The social hall upstairs was the gathering place of early Mesa and the scene of many dances, parties, and other events.

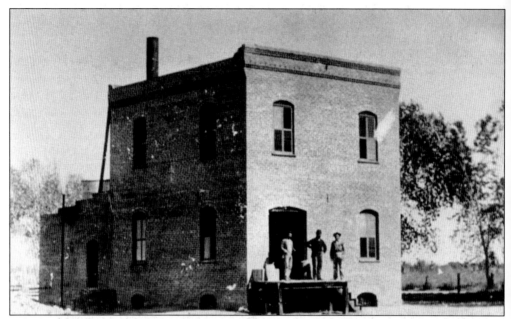

After an earlier mill failed, area farmers had to take their grain to Tempe or Phoenix to be ground. Sometime in the 1880s, area farmers joined together in a cooperative venture to build the Mesa Flour Mill. The mill was run by the Mesa Cooperative Milling Company, incorporated in 1891. Located at what is now the northwestern corner of Main Street and Mesa Drive, the mill provided an important facility to the community. Farmers could now have their grain crops processed into flour locally.

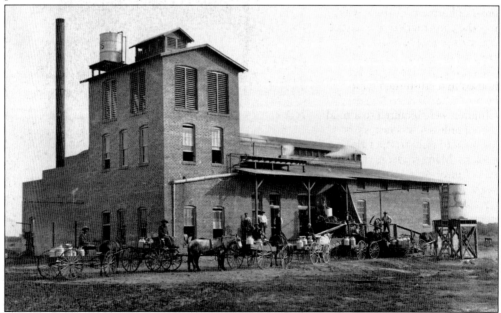

The rise of the ice industry, beginning in the late 1800s, allowed for the storage and long-distance shipment of many produce crops, such as cantaloupes, that would quickly spoil otherwise. These ice companies also provided regular ice service by horse-drawn wagons to homes and businesses in Mesa. Prior to this, ice was brought in from Phoenix at great expense.

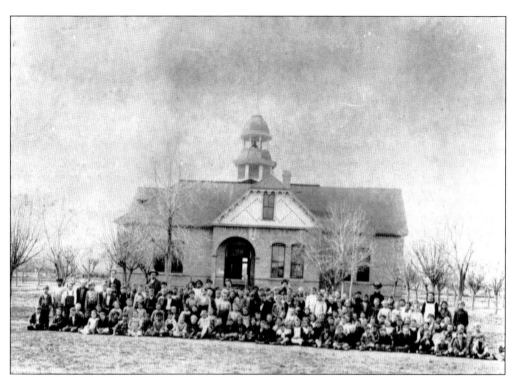

Once the land had been cleared so crops could be planted and shelters had been built, the next order of business for the settlers was the construction of a school. The first school in Mesa was presided over by Mary Ursula "Miss Zula" Pomeroy and was housed in a brush shed built by her father, Francis Pomeroy. Children were required to attend school unless it was necessary for them to work in the field or gardens. Many students attended school until they were 12 to 14 years of age, not an uncommon age to leave school at that time. The first permanent school, an adobe building, was constructed in 1882 at the corner of Center Street and Second Avenue. This was replaced in 1890 with the original Lincoln School, which was demolished in 1920.

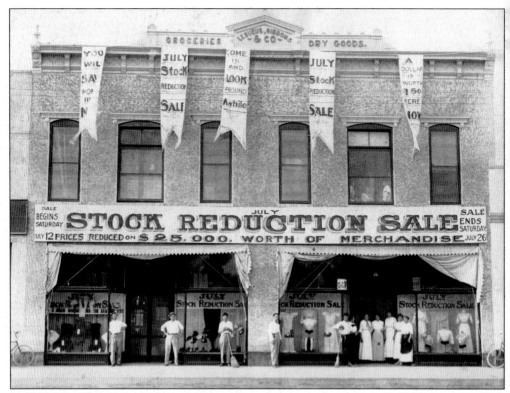

In 1905, John T. LeSueur and his son James formed a partnership with L. R. Gibbons to establish the LeSueur, Gibbons, and Company Mercantile in Mesa. Taking advantage of the economic boom created by the Roosevelt Dam construction project, the LeSueur-Gibbons partnership bought out the old Zeno's cooperative store and built this impressive structure. The business was a great success and continued to do well even after L. R. Gibbons withdrew from the partnership in 1912. In 1926, John sold the store to the Bayless Company of Phoenix.

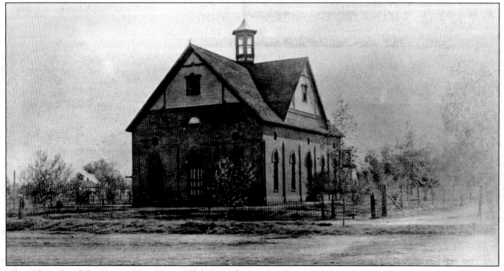

The Church of the Later Day Saints Tabernacle was built in 1896 at the southeast corner of Morris Street and First Avenue. This was the Mormon Church's first permanent structure in Mesa.

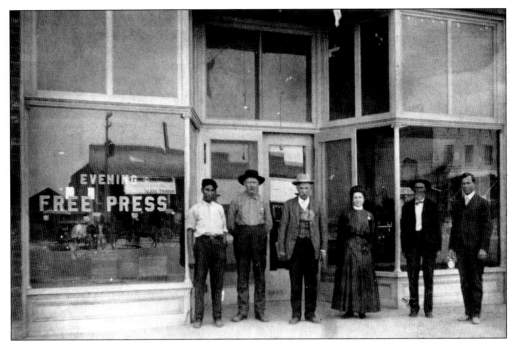

Mesa's first newspaper, seen in this 1908 photograph, began publication in September 1892. Consisting of four pages, the *Evening Free Press* was published weekly. Pages one and four were devoted to local news and advertising, while the two inside pages contained national news stories brought from a newspaper syndicate. It has several name changes over the years, becoming the *East Valley Tribune* by 2000.

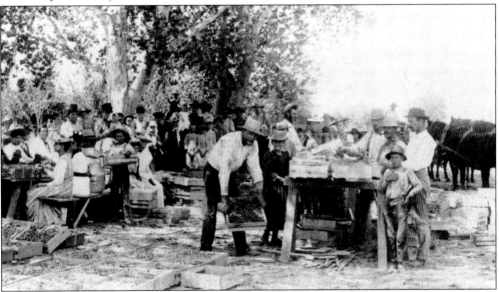

Some of the early crops grown in Mesa included alfalfa, grains, fruit, and an impressive variety of other crops. Grapes, in particular, were an important cash crop and formed the basis for one of the first industries in Mesa and Lehi: winemaking. By 1892, there were at least two major wineries in Mesa. Although forgotten now, at one time winemaking was one of the most important industries in the valley.

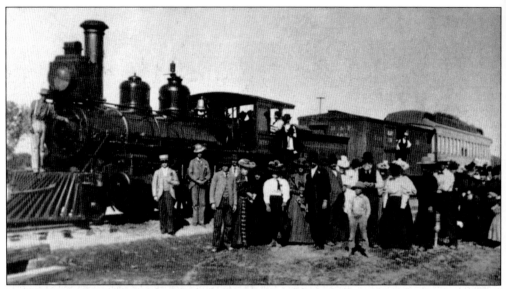

The arrival of the Maricopa and Phoenix Railroad in the Salt River Valley in 1895 was a major milestone for Mesa. The railway line was important for moving the area's agricultural produce into the commercial networks of the nation, as the railhead for the building of the Roosevelt Dam, and for leisure activities. The spur that came into Mesa connected the town to Tempe and Phoenix, and the seven-hour trip by wagon could now be made in 45 minutes. Two trains ran in each direction daily. The first train depot was located at Third Street (now University Drive) between Center and Sirrine Streets (opposite Depot Park, later called Drew Park and then Rendezvous Park). Depot Park was a popular location for picnics and holiday celebrations. Excursion cars ran between Phoenix and Mesa for 60¢ round-trip, and it was not unusual for Phoenicians to travel to Mesa for the day. An all day excursion to Tucson cost $2.75 for a round-trip. This depot was abandoned by 1911.

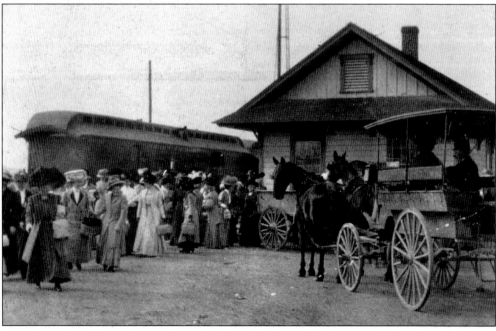

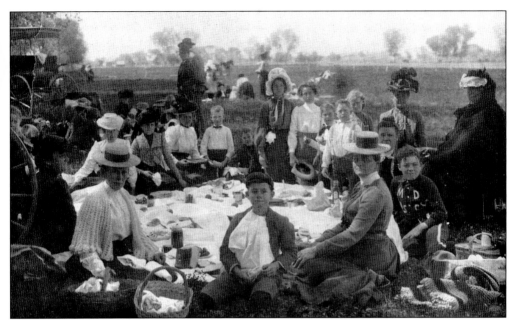

Even though life could be difficult, the citizens of Mesa still found many ways to enjoy it. There were dances, parties, candy pulls, and hayrides. Reading societies were organized; drama groups were formed, and they put on productions in the social hall behind Zeno's Co-operative store. Another popular activity was a picnic in the desert. Everyone dressed in his or her Sunday best for this early-20th-century family picnic.

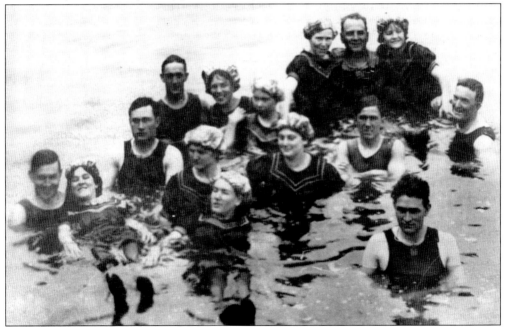

The little town on the mesa top continued to grow and the businesses opening along Main Street helped to enhance the quality of life in Mesa, but times were still hard. Heat was a constant problem. Beating the heat included soaking clothing before going out to work in a field, wetting and hanging sheets in windows and doorways, and swimming in the Salt River and the canals.

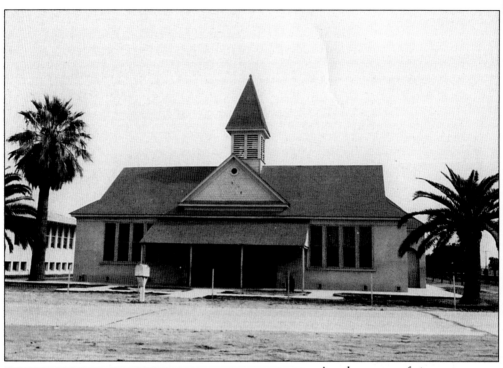

Another group of pioneers, the Rogers, Standage, and Pew families, arrived in Mesa on Christmas Day in 1880. The group settled on parcels of land along what is now called Alma School Road, about a mile west of the town site. The area soon became known as "Stringtown" because the homes were strung out along the road. Others say the name came from the ropes of the tents the settlers lived in before they were able to build homes. Buildings associated with this group include the first home in Mesa, which was constructed of lumber; the Alma Ward LDS Church, built in 1911; and the Alma School. The Alma Ward Church is now the Landmark Restaurant. The school is long gone, but its name lives on in Alma School Road.

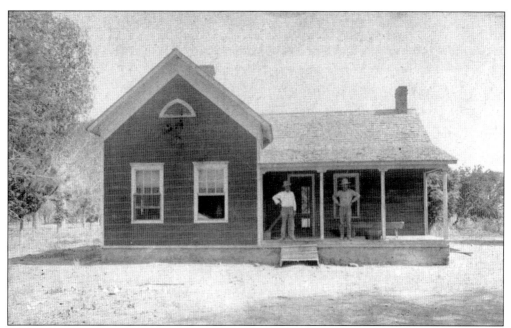

Chancy Rogers built this home for his family in 1882. Constructed of lumber hauled from Prescott, it was painted red and had two porches, three rooms, and a basement. Situated at the southwest corner of University Drive and Alma School Road, the home stood for nearly 80 years before it was torn down in 1960 to make way for a service station.

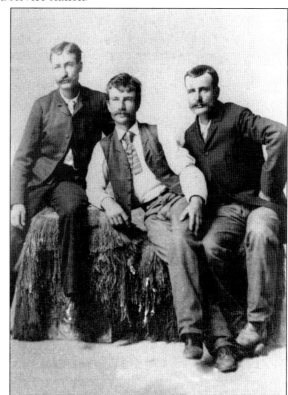

These fashionable young men, Walter (left), Otis (center), and Oscar, were three of the four sons of Chancy Rogers, another of the leaders of the Stringtown group. This photograph was taken about 1895. Oscar, who never married, was affectionately known as "Uncle Doc." The fourth brother, Woodford, is not shown.

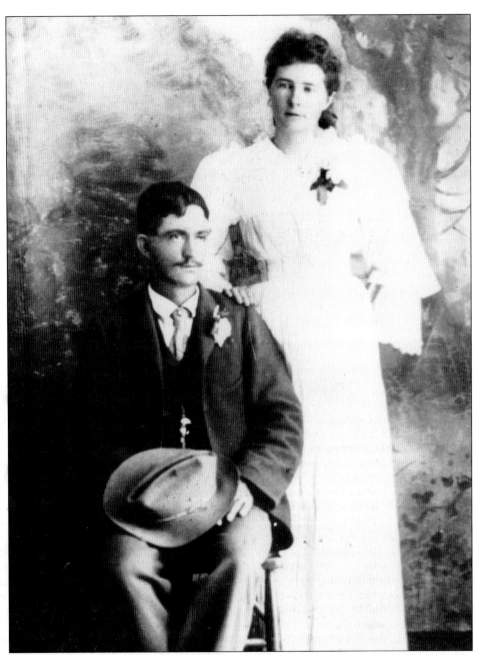

This wedding picture of William Noah Standage Jr. and his wife, Rosalee Holladay Standage, was taken in 1897. William Noah Standage was the grandson of Henry Standage and the son of William Noah Standage, the other two leaders of the Rogers, Standage, and Pew group. When the group reached Mesa on Christmas Eve in 1880, it was the fulfillment of a 30-year dream for Henry. The group first camped at Bond's Corner, located at the southwest corner of Country Club Drive and Main Street while deciding where to homestead. The group decided on parcels of land along what is now Alma School Road, about one mile west of the town site. William Noah Jr. and Rosalee Standage moved into their home at 960 West Main Street, near Alma School Road, in 1897. This house is still standing.

Three

A Watershed Event

Mesa was a thriving community by the end of the 19th century, but the lack of a dependable water supply undermined its future vitality and growth. The Mesa Canal, which supplied water to the community, was a constant chore for the residents as they struggled to fix breaks in the walls. An ongoing drought made the water issue even more important. Dr. A. J. Chandler, owner of the Consolidated Canal Company, took over management of the Mesa Canal in 1891, connecting the Southside and Mesa Canal systems. Improved maintenance and expanded canals allowed more water to flow into Mesa. He guaranteed shareholders in the Mesa Canal Company that Mesa farmers would be the first to receive water.

By the early 1900s, irrigation issues were getting national attention. Phoenix residents, realizing that a dam on the Salt River would spur growth and economic prosperity, helped lobby Congress to create the Bureau of Reclamation. Their efforts paid off when Pres. Theodore Roosevelt signed the National Reclamation Act in 1902, making federal funds available to build dams for irrigation projects in the western United States. Valley farmers created the Salt River Water Users Association, now the Salt River Project, in 1903 to show the federal government that they could cooperate in developing a water reclamation project. Several projects were begun soon after. Ironically, in 1905, the decade-long drought was ended by a flood that hindered the progress of constructing the dams on the river.

Once completed, the projects supported by the Salt River Project and the National Reclamation Act of 1902 paved the way for the phenomenal growth of Mesa and other communities in the Salt River Valley in the 20th century.

Dr. A. J. Chandler was born in Quebec, Canada, in 1859. Chandler attended McGill University in Montreal and Montreal Veterinarian College, graduating with high honors in 1882. Chandler was a livestock inspector in Canada for a short while before moving to Michigan, where he gained a reputation as one of the most expert veterinarians in the area. He was offered a post as the veterinarian surgeon in the Territory of Arizona by the governor in 1887. Lured to the growing West by the opportunities offered outside of his veterinary career, he quickly became interested in the problems of irrigating the desert. Besides his interest in the canals, Chandler owned 18,000 acres by the beginning of the 20th century and began to make plans for a town on a parcel of land known as "Chandler Ranch." In 1912, Chandler opened the town site office of the city, which would eventually bear his name. A true visionary of the potential of the West, Chandler died in 1950. (Courtesy Chandler Historical Museum.)

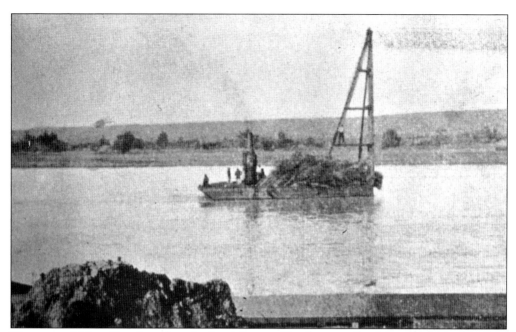

The original Mesa Canal was breached and damaged by the great flood that devastated the area in 1891. Dr. Chandler used innovative approaches to expand and improve the Mesa Canal, known as the Consolidated Canal. He moved the head of the canal upstream, away from the porous soils with high seepage rates that had robbed the original canal of water. The water saved by this new design could serve both Mesa and points south. To save labor costs for canal construction, Chandler built the world's largest steam-powered dredge to excavate the canal. Floating on the canal water, the dredge dug the new canal just ahead of itself. People came from other states to see this marvel of engineering.

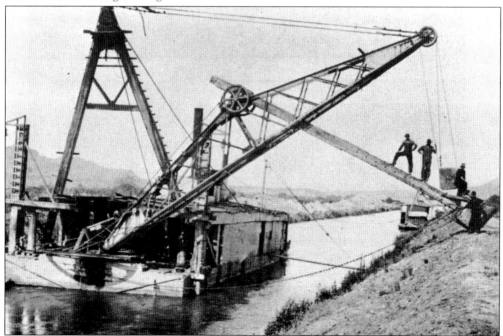

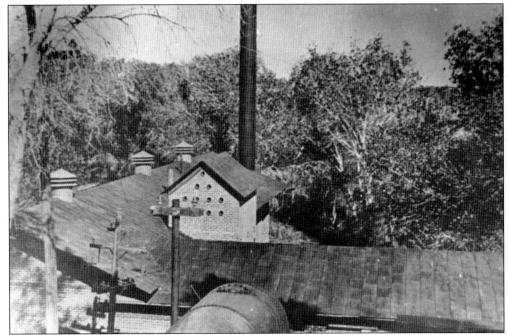

Dr. Chandler engineered the Consolidated Canal to carry the full water load for the Hayden or Tempe Canal, bringing water from the river to the mesa top. The water was then dropped off the terrace through large pipes and into the first hydroelectric generating plant in the valley, bringing electricity to city in 1898. Later he sold the plant to the city of Mesa, which began operating utility companies as a source of revenue.

Canal Guards, or *zanjeros*, supervised the daily operation, maintenance, repair, and distribution of water through the canals. How water was distributed depended upon the amount available. During times of drought, irrigation water was rotated among farmers, meaning that each shareholder received irrigation for a specific length of time or a set quantity of water. When water was plentiful, shareholders received irrigation continuously or as was needed.

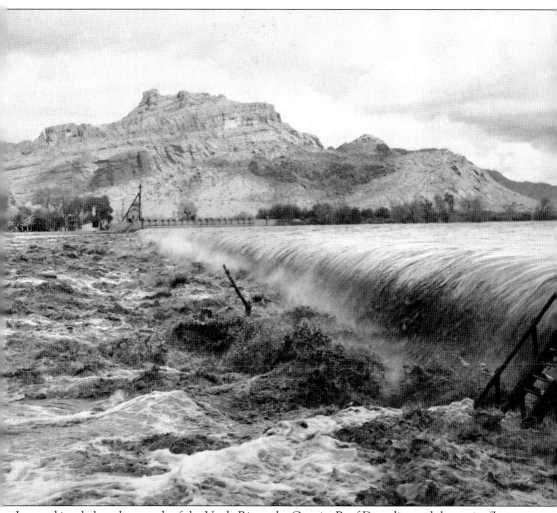

Located just below the mouth of the Verde River, the Granite Reef Dam diverted the entire flow of the Verde and Salt Rivers into the main irrigation canal systems that ran along the north and south sides of the valley. Great celebrations marked its completion in the summer of 1908, as many of Mesa's residents traveled out to the ceremonies to join the festivities and hear local and territorial dignitaries speak.

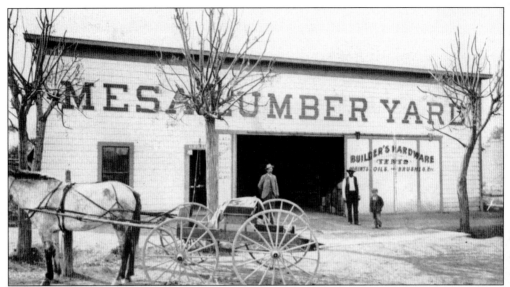

Because of construction of Rooseveld Dam, a period of prosperity came to Mesa. The demand for goods and services increased, and new businesses opened to accommodate the needs of the workforce. Farmers expanded agricultural production to provide enough food for the thousands of workers and draft animals. New businesses included the Mesa-Roosevelt Stage Company, the Mesa Transfer Company, and a Wells Fargo branch. The mercantile and hardware stores of O. S. Stapley Company, Mesa Lumber Company, and the C. C. Manning Hardware Company sprang up in response to construction needs at the dam. Because drinking was forbidden at the dam site, Mesa became the gathering spot for the workmen as they came into town to drink, play cards and pool, and carouse. At the peak of construction, Mesa had at least nine saloons, several pool halls, and a number of prostitutes. More than a few businessmen in Mesa made a healthy profit providing these services to the construction workers.

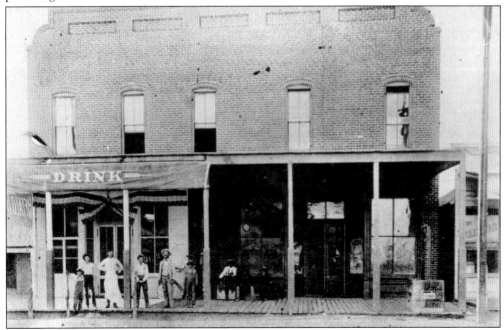

Mesa was the railhead for the dam construction, and everything shipped to the project went through Mesa. From Mesa northeast to the dam site lay some of the most rugged country in Arizona. As there were only some old Native American trails, it was necessary to build a road to link the two. Work was begun in 1903 and was completed in 1904. Apaches were paid 50¢ a day to build the 60-mile stretch of road. Originally named Roosevelt Road, it was renamed the Apache Trail in 1914.

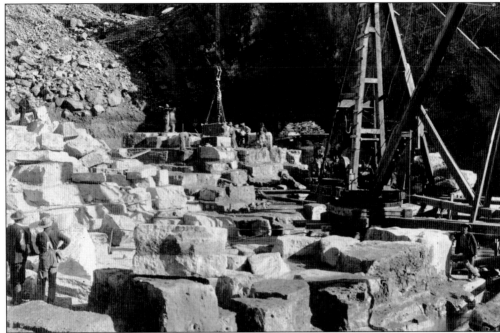

Views of Roosevelt Dam under construction were taken by Walter J. Lubkin, the official government photographer for the project. Lubkin took thousands of photographs of the progress of the dam, documenting the workers and equipment of this enormous project, as well as the contributions of the Native Americans who worked on the road to the dam site. He had a studio in Mesa, and his pictures of the dam and other Western subjects have been published hundreds of times, often without credit. Today he is considered to be one of the most important historic photographers in Arizona and the Southwest.

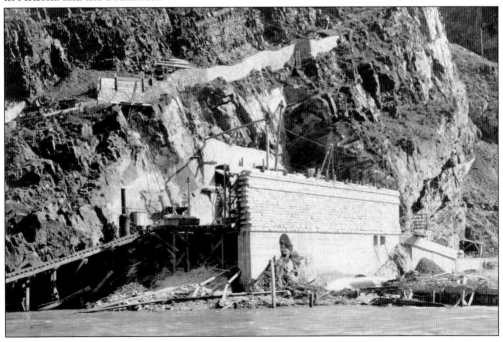

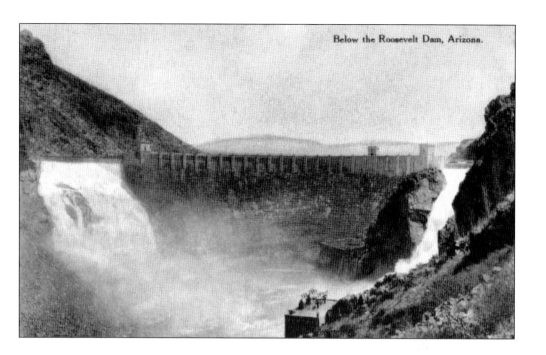
Below the Roosevelt Dam, Arizona.

The Roosevelt Dam was the first project to be approved under the Reclamation Act of 1902 and the first to repay the government in full. The first stone was laid in September 1906, and the final stone in February 1911. Once completed, the reservoir created by the dam had the capacity of 1,284,000 acre-feet and covered 16,230 acres of land. Also covered by the creation of the reservoir were the temporary towns that had sprung up to house the construction workers.

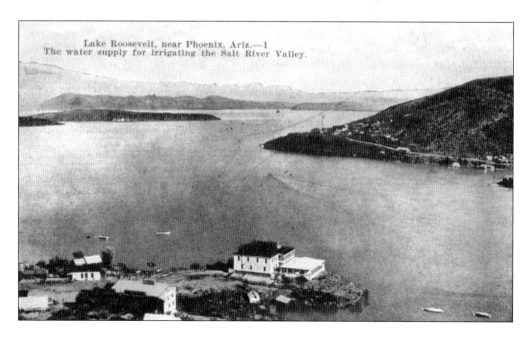
Lake Roosevelt, near Phoenix, Ariz.—1
The water supply for irrigating the Salt River Valley.

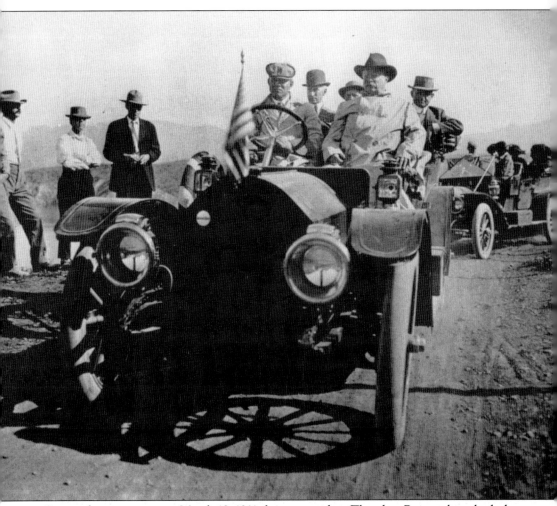

During the ceremonies on March 18, 1911, former president Theodore Roosevelt pushed a button that released water from the dam that bears his name. It was the first large-scale irrigation project to be financed by the federal government under the Reclamation Act of 1902, and it provided stable water for both urban and agricultural use. Residents of Mesa finally had a year-round reliable source of water. At the time of its dedication, Roosevelt Dam was the largest in the world and is still the largest masonry-rubble dam in existence.

Four

FROM FRONTIER TOWN TO GEM CITY

By about 1915, Mesa was described as a city of wide streets, beautiful homes, and luxuriant foliage. A steady supply of water assured by the completion of Roosevelt Dam allowed cultivation to spread, business to thrive, and city to grow. Population boomed, increasing from 722 residents in 1900 to 1,692 by 1910. A popular term for the city at that time was "Gem City." Life was good in the little town on the mesa top.

Although founded by Mormons, Mesa was ethnically and religiously diverse by the time Arizona gained statehood, in 1912. Native people had been in the area from the beginning, and Mexican American families began to settle in town in the late 1800s. New waves of settlers began to arrive in the area in the early 1900s, lured in part by work opportunities at the dam site. People of Chinese, African American, Japanese, and Arab descent moved into the valley, opened businesses, and began to farm.

Agriculture was the backbone of Mesa's economy. At the heart of this were the alfalfa and dairy industries, both of which prospered in the wake of the construction of Roosevelt Dam. Because of the success of the alfalfa crops, ranching also became an important part of the economy. Other crops also flourished, including vegetables, lettuce, grapes, cantaloupes, and citrus.

Long staple cotton emerged from a variety of experimental crops to become a major cash crop in the region. Cotton was not new to the area; the short staple variety had been first grown by the prehistoric Hohokam. Since the early 1900s, the federal government had been experimenting with the long staple varieties. Long staple cotton originated in Egypt, but the advent of World War I cut off access to that source. After 1914, industries that relied on long staple cotton turned to the Salt River Valley for their needs. When the United States entered World War I in 1917, the demand for long staple cotton increased as American industry responded to the needs of the military. Mesa had come full circle from its frontier beginnings, and local residents celebrated the town's growing prosperity.

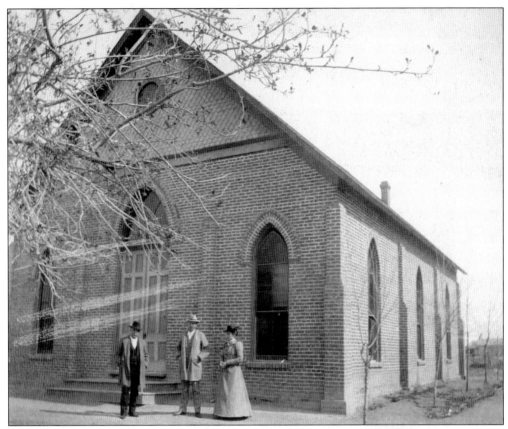

Although Mesa was originally founded by Mormon pioneers, other denominations were well established by the early 1900s. Baptists and Methodists built elegant and imposing churches by the late 1890s, and city records noted there "is a good population of them." The first Baptist church was erected at the corner of Macdonald Street and First Avenue in 1895 at the cost of $2,500. The original Methodist church was located on First Avenue, just east of town's center in 1893. At the time of its construction, the church had a congregation of just 12 members. The one-room brick facility was later replaced with a larger facility. The Franciscans founded the first Catholic Mission at the corner of Second Street and Country Club Drive in 1908. This mission was later replaced with the current Queen of Peace Church located at First Street and Macdonald Street.

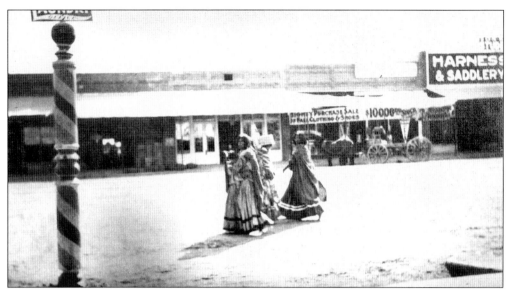

The Pima people, like these women walking along Main Street, were a familiar sight for many in Mesa. Up until World War II, the Pimas would ride into town in their wagons to do their shopping. They would park their wagons along Pepper and Robson Streets, where the Basha Grocery Store was later built. The Arizona Museum for Youth occupies this site today.

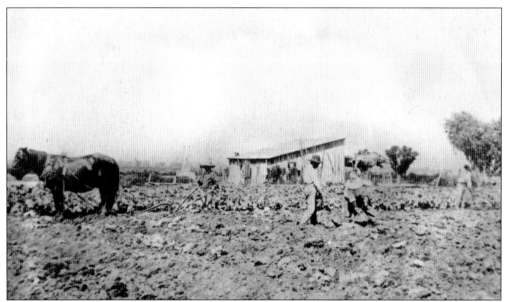

The Japanese were also among the early pioneers who settled in both Lehi and Mesa. Early settlers included Kuratara Ishikawa, who arrived around 1909, and Mingo Ikeda, who arrived about 1910, followed by many others throughout the decade. Primarily farmers, they experimented with a wide range of vegetables and fruits to see how these crops could adapt to the desert environment. Many of these experiments, such as cantaloupes, went on to become major agricultural crops in the area.

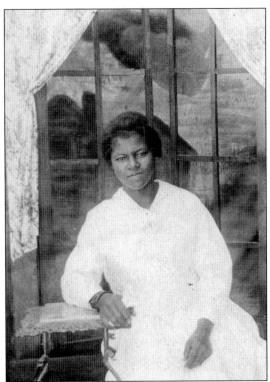

The McPherson family was the first African American family to settle in Mesa. Alexander McPherson, an ex-slave and retired veteran of the Spanish-American War and the U.S. 10th Calvary, brought his wife, Clara, and their four children to the town in 1905. They lived just north of Chandler Court, at the corner of Macdonald Street and Pepper Place. Alexander was a teamster, carrying fuel to the Roosevelt Dam construction site, and later was a stable caretaker. One of his daughters, Lucy McPherson Hanson, is shown here.

The first telephone switchboard, operated by the Consolidated Telephone Company, was located in the back of Petersen's Grocery at the corner of Main and Macdonald Streets. At the time telephone service began in 1902, there were fewer than 800 residents in Mesa. The first long-distance call came from California in April 1906 and relayed the news of the devastating 1906 San Francisco earthquake and fire. The switchboard in the photograph opened in 1910.

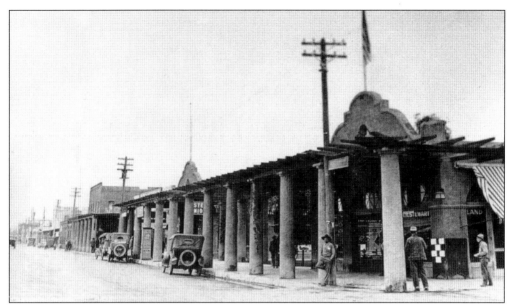

Mesa's first shopping center and office complex, Chandler Court, was the hub of Main Street. Built in 1908 by Dr. A. J. Chandler, the offices and stores were situated around an open courtyard with a fountain. It was the first building to use evaporative cooling in Mesa. Located at the northwest corner of Main and Macdonald Streets, Chandler Court was home to Everybody's Drug, Pomeroy's, and Petersen's Grocery, among other businesses. The columns and lattice work are still here today.

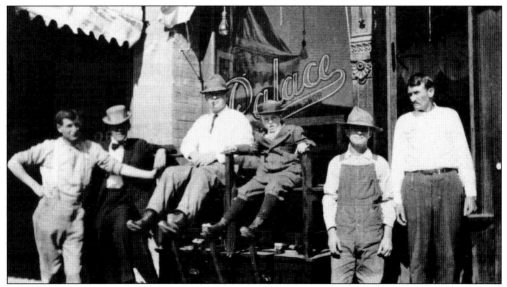

These gentlemen stand in front of the Palace Barbershop, located on Mesa's Main Street. Note the shoeshine stand in front of the store. Mesa also had a skilled seamstress, a tailor, and a beauty shop.

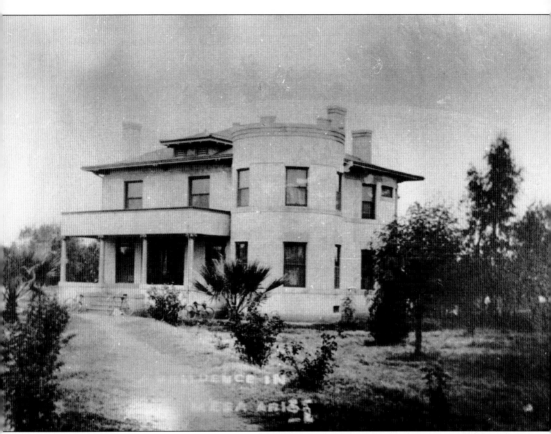

Ralph Palmer was born in Marquette, Michigan, in 1875, was educated at the University of Michigan, and received most of his medical training at Cook County Hospital in Chicago. After completing his medical training, and suffering from poor health, Dr. Palmer followed his older brother to Arizona in 1902. He practiced in Prescott and Camp Verde before becoming chief surgeon at the construction site of Roosevelt Dam. In 1906, Dr. Palmer moved to Mesa, where he opened his first clinic on North Center Street. During his tenure as mayor, between 1910 and 1912, Dr. Palmer led the effort to raise over $10,000 to purchase the John T. LeSueur home. This became the Southside Hospital, the first in Mesa. In 1920, Dr. Palmer began the drive to establish the Mesa Rotary Club. He became a founding member and its first president. He died at his home in Phoenix in 1954.

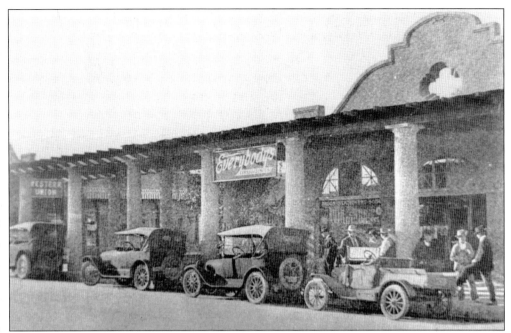

Having to rely on the patent and homeopathic medicine of his day and dissatisfied with the quality of the medicine he could purchase, Dr. Palmer decided to open his own pharmacy in 1906. Located in Chandler Court, Everybody's Drug was a fixture in Mesa for almost a century. Its popular soda fountain and lunch counter made it a hub of the downtown business district. Among the customers was Teddy Roosevelt, who visited the store when he was in the area to dedicate the Roosevelt Dam. The soda fountain shut down in 1989, and the store itself closed in the late 1990s.

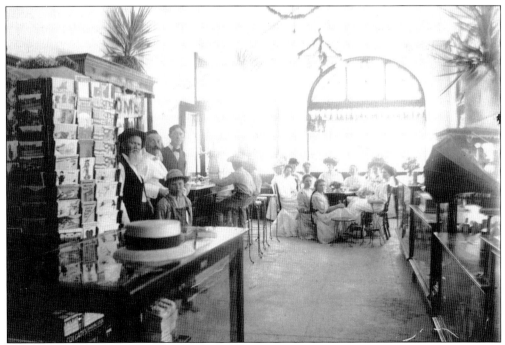

Mesa's statehood rally was held near the intersection of Main and Macdonald Streets in late 1911. There was a broad range of support, and the campaign for statehood was successful. Pres. William Howard Taft signed the statehood proclamation, making Arizona a state on February 14, 1912. George W. P. Hunt was elected as the first governor, and Carl Hayden was the first congressman to represent Arizona in the U.S. House of Representatives.

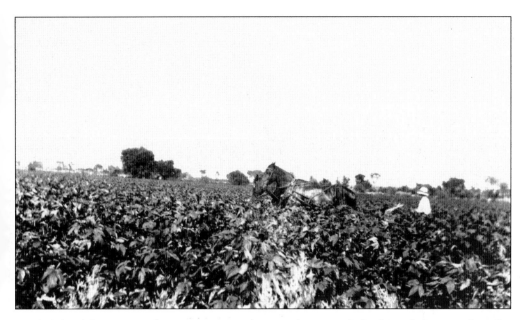

By 1912, local farmers were beginning to grow long staple cotton, helped greatly by water from the newly opened Roosevelt Dam. Cotton soon proved to be a profitable crop, requiring the building of a cotton gin. Farmers believed in the future of cotton and formed a co-op called the Mesa Egyptian Cotton Gin. Cotton was sold to cotton mills in the east for clothing and was used in the manufacture of automobile tires. By the time the United States entered World War I, cotton was grown everywhere, including back yards and vacant lots. Mesa's first cotton boom had begun.

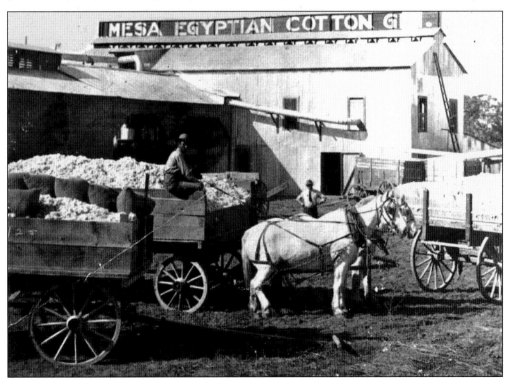

Alfalfa provided feed for livestock, pasture for grazing, and fertilizer for soil. The success of the alfalfa crop helped boost the dairy industry. Milk production in Mesa by 1912 was so great that the city supported two dairies. The ranching industry also benefited from the alfalfa crops. By the early 1900s, conditions on the northern rangelands had deteriorated greatly, probably because of overgrazing. Cattle and sheep ranchers brought their herds south for the winters to the Salt River Valley to graze on alfalfa pastures. As the size of herds increased, so did the acreage planted in alfalfa. The presence of these herds in the area provided an additional source of income beyond the selling of alfalfa as cut hay.

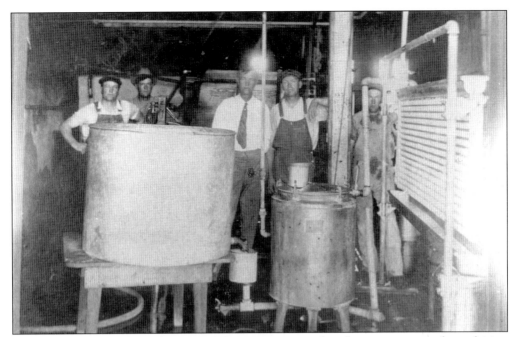

Dairy farming and milk production in Mesa were so great that the town supported two dairies, the Mesa Creamery and the Mesa Dairy and Ice Company. Founded in 1895, the Mesa Dairy and Ice Company provided regular ice service and milk delivery by horse-drawn wagons to homes and businesses in Mesa. These workers are shown by the dairy's milk cooler around 1907.

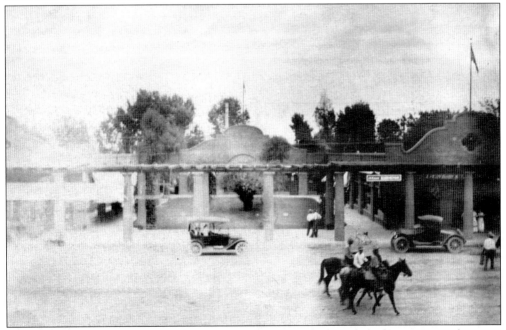

This view of the front of Chandler Court in around 1915 clearly shows how the times were changing. By 1910, Mesa had 1,692 residents, more than twice the 722 people in 1900. And while horses continued to be an important part of Western and agricultural life, the number of automobiles was growing. There were 109 automobiles and trucks in Mesa by 1912.

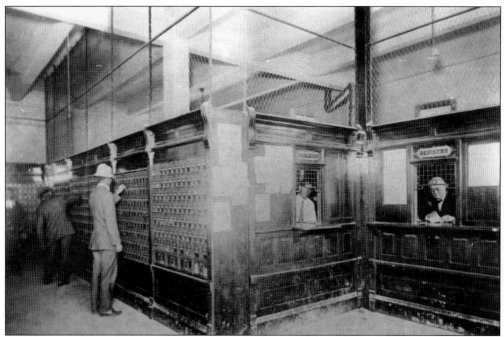

Mesa's first postmistress was Fanny VanCott Macdonald, the wife of the first mayor. She ran the post office out of her small general store at the southwest corner of Main and Macdonald. Originally the post office was referred to as "Zenos," because another town in Arizona was called Mesaville. The post office was established under the name of Mesa in 1889, when the Mesaville post office was closed. This view is from 1914.

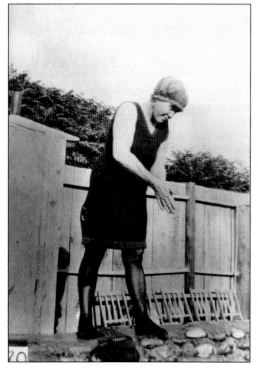

Keeping cool in the desert heat was a priority for the citizens of Mesa in the days before air-conditioning. Louisa Rogers is about to dive into the old Crystal Pool in this 1916 photograph. Rogers was one of the early residents of the town, arriving in the Salt River Valley with her family in 1880 at the age of 12.

Five
WORLD WAR I AND MESA

For the citizens of Mesa, the first 17 years of the 20th century were ones of peace and prosperity. Roosevelt Dam was constructed, bringing with it a steady, controlled supply of water for both agricultural and urban use. The town on the mesa top continued to grow as it began to expand outside its original one-square-mile border.

The demand for long staple cotton increased as the war in Europe raged on. The continued unavailability of Egyptian and other foreign long staple cotton because of the war embargo fueled a frenzy of cotton production in the area. Cotton was planted everywhere, including in vacant lots, often to the detriment of other crops. The dairy industry, in particular, was hit hard, as dairy herds were sold and grazing lands planted with cotton.

While the citizens of Mesa were aware of world events, the horrors of the war in Europe seemed far away from life in Mesa. Unfortunately the conflict came home to Mesa in August 1917, when the United States entered the war and the draft began.

As the men left to fight in Europe, residents sent them off with parades, receptions, and parties. Patriotic citizens held war bond drives, assembled boxes for the soldiers, and anxiously awaited word from the front. The drama of the war engaged Mesa citizens, many of whom congregated at the Majestic Theatre on Main Street to see the latest images of the war in Europe. Most of Mesa's soldiers returned home safely, but some families received the dreaded news of the death of their loved one. Over 100 men from Mesa served overseas during World War I, and at least 8 died, although the exact number is not known.

Although the war was difficult for Mesa in many ways, it brought great economic wealth to Mesa and Lehi. Nearly all of the crops that Mesa produced during the war were in high demand. Agricultural production during World War I helped bring Mesa into the national economy and tied the city to global events.

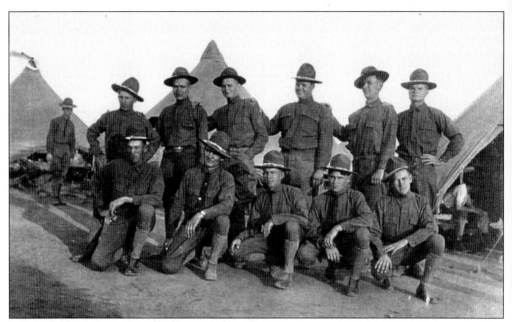

Before the beginning of World War I, members of the Arizona National Guard were posted at the Mexican border. These men, of Company D of Mesa, posed for this photograph on June 21, 1916, in their encampment at Douglas, Arizona.

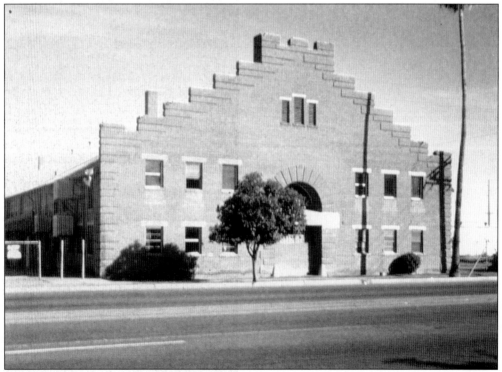

Mesa was home to a company of National Guardsmen whose base of operations was the local armory. Soldiers were assigned to guard Granite Reef and Roosevelt Dam against potential saboteurs who might harm the local water supply.

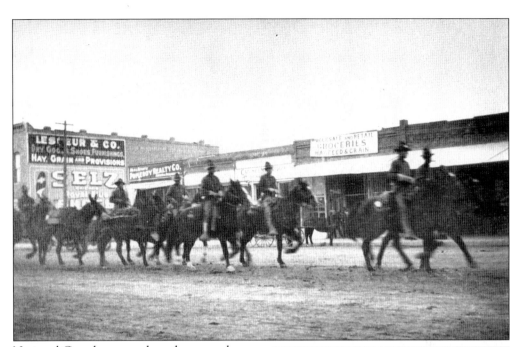

National Guardsmen, such as these members of a cavalry unit, were a familiar site as they rode through town on their way out to guard canals and dams throughout the area. It was vital to protect these assets, which were so important to the agricultural products needed to support the war effort.

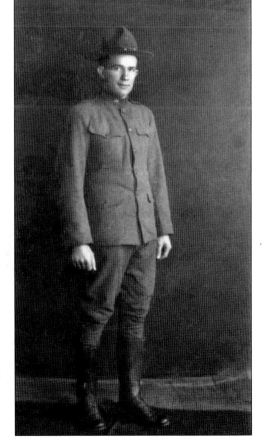

Over 700 men from Maricopa County were called up in the first draft of 1917. Of the first 158 men who passed the physical examination and were inducted into the army, 36 were from Mesa and 3 were from Lehi. These soldiers represented every segment of the population. Peter C. Peterson was one of the men from Mesa who served during World War I.

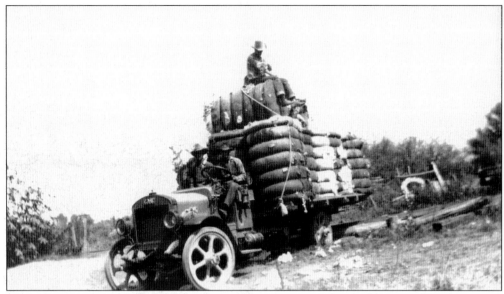

The military's need for long staple cotton, used in tires, gas masks, uniforms, airplane fabric, and balloons, created additional demand for the area's cotton crop. Cotton and the other agricultural products produced in Mesa, such as alfalfa for hay, were key to the success of the war effort and to the growth of the agricultural industry in the area.

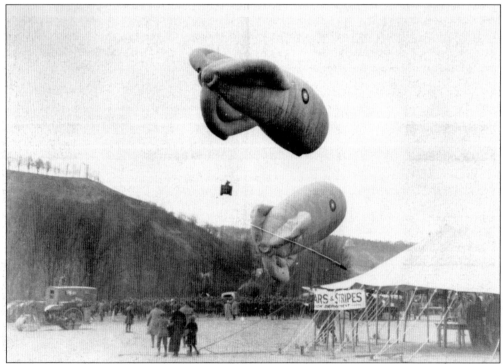

World War I observation balloons, or dirigibles, such as those seen here, were sent up behind the army's lines to survey the battlefield and see what was coming. Long staple cotton, the variety grown in Mesa, was used to manufacture these balloons.

Cotton was not the only agricultural product important to the war effort. Ranchers benefited as the demand for cattle for beef products grew. Alfalfa and other feed crops, wheat, fruits, and vegetables, as well as horses and mules were in high demand. Statewide, the need for copper also grew, creating jobs in the copper mines. These men are raking hay for animal feed.

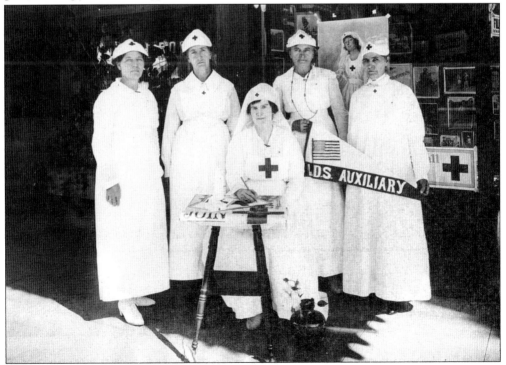

These ladies, members of the LDS Auxiliary of the American Red Cross during World War I, helped the war effort at home.

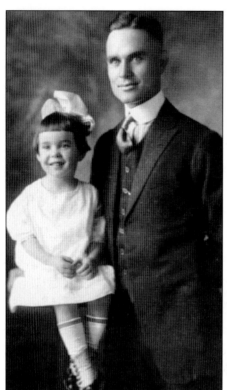

Joseph "Dode" Morris was inducted into the army on September 19, 1917, and left with the Maricopa County contingent. He was eventually sent to the front lines in France as a member of Company 340 of the Field Artillery. Dode was killed on October 21, 1918, just three weeks before Armistice Day, leaving behind a widowed mother, and Maxine, his three-year-old daughter. The Mesa VFW Hall commemorates his service.

The mother of Dode Morris was invited to attend the Luke Air Memorial Tournament in return for a $1 donation to the Luke Memorial Fund. The tournament was held on June 28, 1919, in honor of Frank Luke Jr. and the other men from Maricopa County who had died in World War I. Another soldier from Mesa, Marion Rogers, is also listed on the program.

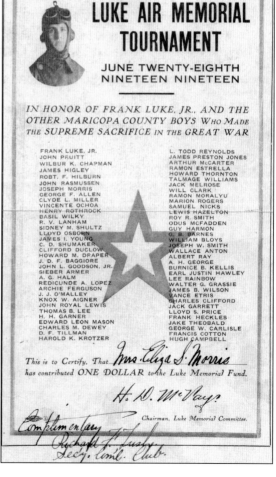

```
                    Headquarters Company, 18th Infantry,
                         France, October 18, 1918.
```

Mr. Otis E. Rogers,

 Mesa, Arizona.

My dear Sir:

Although the War Department at Washington will have informed you of your son's death in action on October 4, 1918, before this letter reaches you yet these few lines will serve to let you know that your son was not unforgotten by those who knew him in this turmoil of war. Although he was with this organization only a short time yet in that brief period he made many friends who deeply and truly regretted his loss. They valued him as a true comrade and an excellent soldier, and considered him as always ready to do whatever duty he might be called upon to perform. Although his death is a painful bereavement to you yet he sacrificed his life in one of the greatest engagements in which the American Army has ever participated in this fight for freedom and liberty.

His comrades join with me in extending to you our heartfelt sympathy to you in the loss of your son and are proud to have been with him and to have called him "Comrade".

 Very truly yours,

 B.H. Henderson,
 1st Lieut., 18th Infantry,
 Commanding.

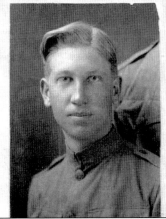

Marion Rogers was called up in a later draft and was a member of the 18th Infantry in France. Marion was killed in action on October 4, 1918. In this letter to his father, Otis E. Rogers, his commanding officer described him as "a true comrade and excellent soldier" who was "always ready to do whatever duty he might be called upon to perform."

By the fall of 1918, victory in Europe seemed definite. But in mid-September, an unseen enemy invaded the United States and quickly made its way to Arizona and to Mesa. The Spanish Influenza struck quickly, often killing its victims within hours. To try to halt the epidemic, officials banned public gatherings and closed churches, schools, and movie theaters throughout the state. In Mesa, the Franklin School served as an emergency hospital to handle those infected. For those who could pay, the cost was $15 a week.

Six
Diversifying Mesa's Economy

Cotton was the backbone of Mesa's economy at the end of World War I. Following the war, a general national economic downturn coupled by a drop in demand for long stable cotton for military goods and the renewed availability of Egyptian and other foreign cotton in the market place caused the cotton market to crash in 1920–1921. Much of the 1920 crop went unsold.

The cotton crash hit Mesa hard. The price of cotton dropped almost overnight from $1.20 a pound to less than 20¢ a pound. Farmers had invested so much money in their cotton that to harvest the crops would cost more than the cotton was worth. Many left their fields unharvested. Commercial business declined as a result of the crash because people had less money to spend. The effects of the cotton crash lasted through the mid-1920s, sending Mesa into its first major economic depression, the likes of which it residents hoped they would never see again.

Farmers realized they needed to diversify their crops again to create a more stable economic environment. While cotton remained an important crop for decades to come, the dairy and cattle industries rebounded and citrus production began to play an ever-increasing role in the economy.

Mesa still showed signs of prosperity despite the cotton crash early in the decade. Residential tracts expanded as landowners built new homes and development continued to spread beyond the boundaries of the original town to become future neighborhoods, such as the Evergreen and Temple Districts.

The first subdivision to welcome African Americans as buyers was the Mitchell Addition, created in 1920 and located east of Center Street and north of University Drive. Joining with another subdivision, it became known as the Washington neighborhood.

Businesses grew steadily to meet the new demands. The variety of clubs, social organizations, and churches were a testament to how vibrant the community was becoming. The clearest sign of Mesa's prosperity came in the latter half of the decade, when its designation changed from "town" to "city."

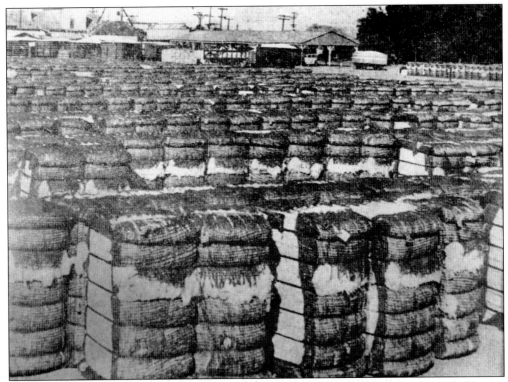

Cotton acreage doubled in just a year, from about 90,000 acres in 1919 to nearly 180,000 acres in 1920. This was a dramatic increase from 1915, when cotton accounted for a mere 3,500 acres. The surging cotton market brought up to 80¢ per pound in 1919, a $400 return on a 50-pound bale of high-grade long staple Pima cotton. It is easy to see how local farmers went "cotton crazy," reducing crop diversity by plowing under other crops and even selling dairy cattle to raise capital to grow cotton. Farmers also set up army surplus tents to house the migrant farm workers hired to pick it. These tents were on the Crismon farm in Lehi in 1919.

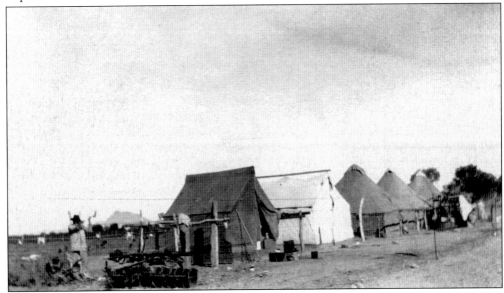

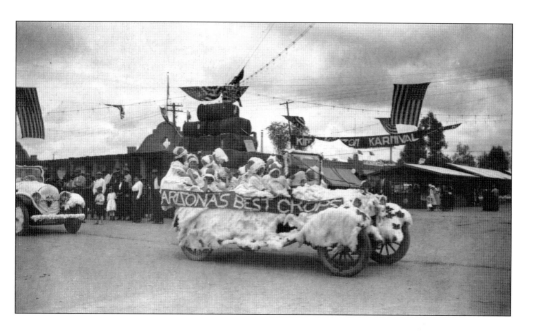

Cotton was king in Mesa by the end of World War I, and the city held an annual cotton festival, the King Kotton Karnival. The first festival was held in October 1919 as the city played host to thousands of visitors from all over the Salt River Valley and the greater Southwest. The three-day event was an opportunity to showcase not only cotton, but the area's other agricultural products as well. The main carnival area covered several city blocks on Macdonald Street, just north of Main Street. Featured attractions included a parade, a Ferris wheel, boxing tournaments, and baseball games. The Sacaton Indian School Band was among the performers. Dozens of booths featured displays by both large companies, such as Goodyear, and local businesses.

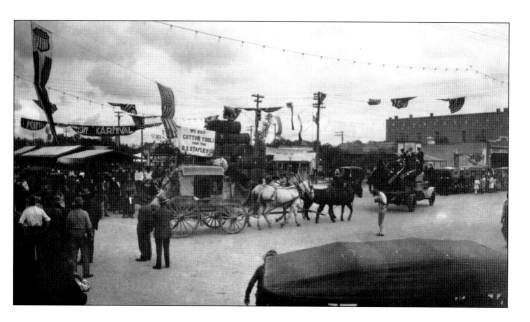

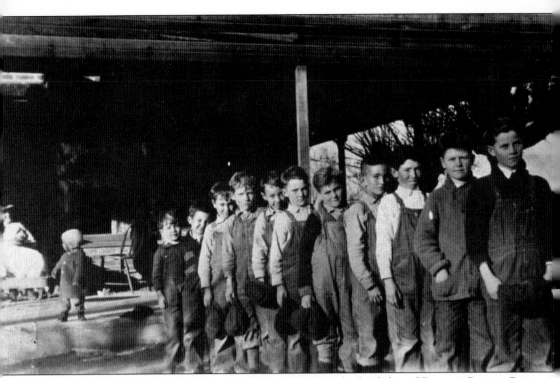

These boys posed for a photograph while celebrating the birthday of Denvon Rogers. Rogers, fourth from the left in the line of boys, was born on January 12, 1913. The party was held at the home of Woodford Rogers, Denvon's grandfather, in 1918 or 1919. Denvon's great-grandfather was Chancy Rogers, one of the leaders of the Rogers, Standage, and Pew group who settled the area known as Stringtown. Today Westwood Plaza occupies the site of the home.

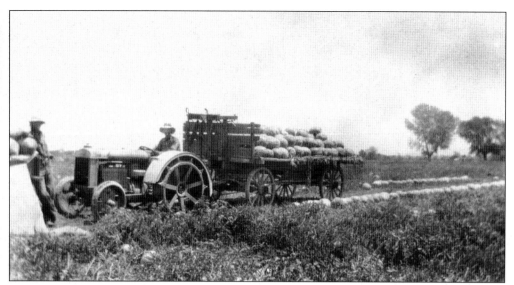

By 1920, some of the crops grown in and around Mesa in addition to cotton were alfalfa, corn, barley, citrus, and melons. There were numerous orchards and truck gardens. Crismon Farm produced this load of melons in 1919.

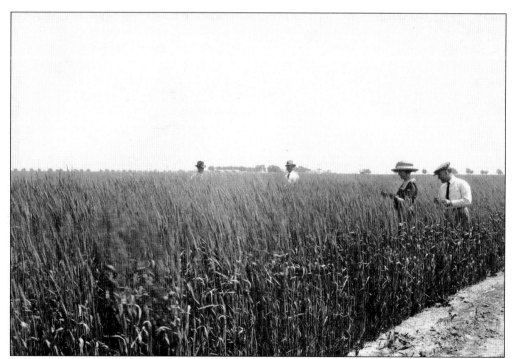

Wheat was an important crop for Mesa during World War I and in the years after. These people are standing in one of the wheat fields around Mesa in the 1920s.

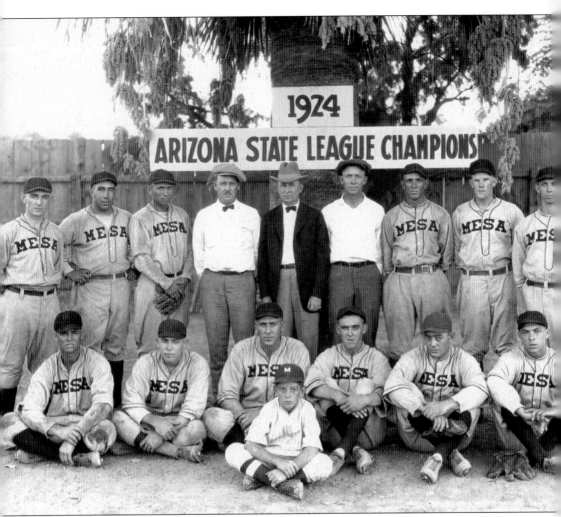

Mesa has enjoyed a long love affair with baseball. Mesa High School fielded a baseball team early in its history, and the team won the state championship in 1913. An exhibition game played in 1919 generated great interest among the city fathers. The newly formed Mesa Allstars played the Chicago White Sox. And although the White Sox won by a score of 8-1, baseball was in Mesa to stay. An organizing meeting was held in Phoenix to form the Salt River Valley Baseball League, with regularly scheduled games throughout the valley. Representatives from Mesa, Phoenix, Chandler, Glendale, Casa Grande, Tempe, and Superior attended. Mesa's team became the Mesa Jewels in 1921. Throughout the 1920s and until the 1950s, Mesa had a series of semi-pro and little league teams that played on the baseball field at Rendezvous Park. This team won the 1924 Arizona State Baseball League Championship.

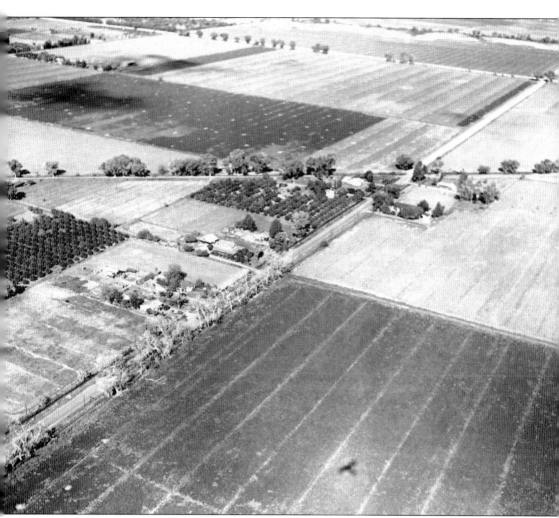

The number of acres planted in commercial citrus groves grew steadily during the years following World War I, increasingly a part of the newly diversified economy. The first successful large-scale commercial citrus groves, such as the Habeeb and McKellips farms, date back to the 1920s. The introduction of refrigerated railway cars able to transport perishables and the increasing awareness of the benefits of Vitamin C found in orange juice and other citrus products created a big market for these fruits.

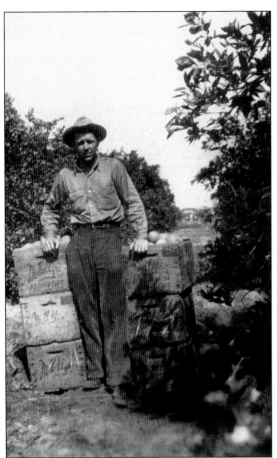

McKellips Citrus Groves hired J. C. Franks for $1 a day and a rent-free cabin at the labor camp. By 1931, he was manager of the groves, a position he held until 1957. Franks was responsible for every phase of the growing cycle, including the planting, watering, cultivating, fertilizing, and harvesting, as well as overseeing the hired hands. He also kept the financial books and wrote out the payroll checks. (Courtesy Joan Franks Gannon.)

As citrus production increased throughout the 1920s, cooperative citrus associations, including the Sunkist Marketing Cooperative, were created or moved into the Salt River Valley to help the citrus farmers market their crops. The Mesa Citrus Growers Association was formed in the late 1920s to meet the specific marketing needs of Lehi and Mesa growers. By the end of the decade, citrus production was well on its way to becoming one of the staple industries in Mesa.

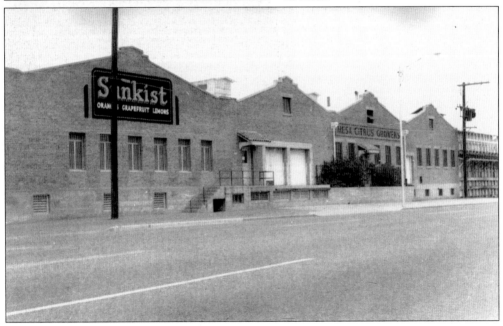

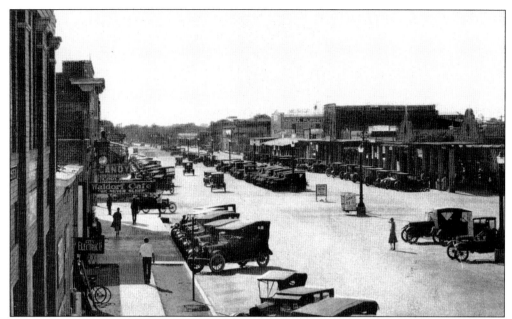

This view looking west along Main Street reveals the city's growth over the decades. The number of automobiles lining the street documents Mesa's expanding prosperity. The ever-increasing sales of automobiles and trucks, as well as the growing use of rubber tires on farm equipment helped the cotton market rebound in the second half of the 1920s. Goodyear's new "Supertwist" cotton cord strengthened tires for the next few decades.

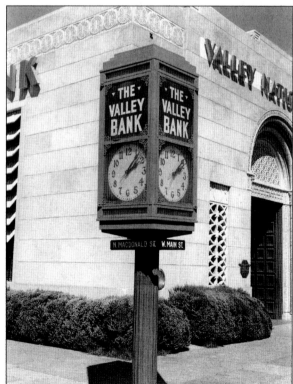

The beautifully ornate Valley National Bank was built during the 1920s at the northeast corner of Main and Macdonald Streets, opposite Chandler Court. While the bank is long gone, its original clock still keeps time at that corner today.

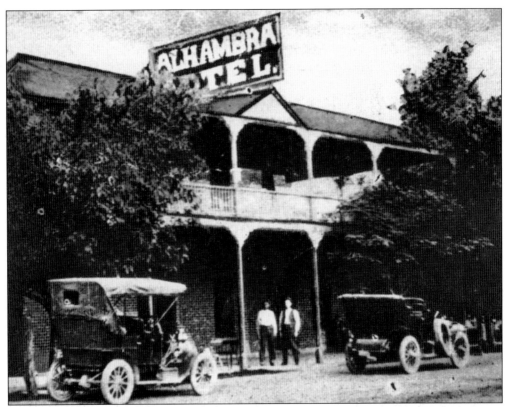

Among the many new structures downtown were the posh Metsford Hotel (1921), the Nile Theater (1924), and the Alhambra Hotel. Originally built in 1894 at a cost of $4,000, fire destroyed the two-story structure in 1921. Soon after, this luxurious hotel was built.

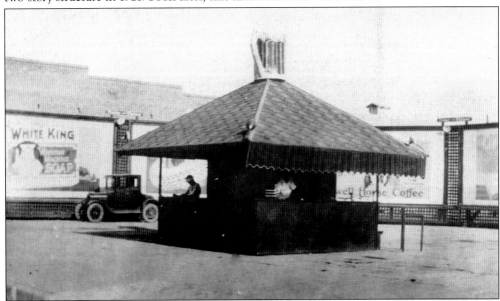

Drive-in restaurants began to appear in Mesa as more and more people obtained cars. This root beer stand was a popular drive-in in the 1920s.

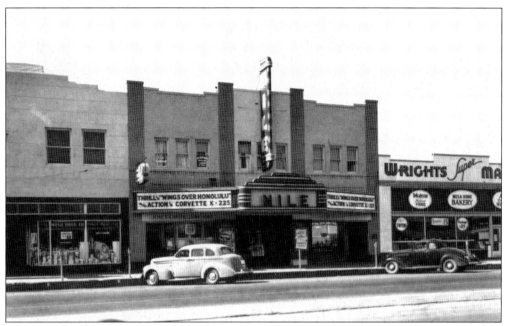

The Nile Theatre, located on Main Street, was built in 1924. The first movie shown was *The Seahawks*, starring Wallace Beery. The theater remained a focal point for entertainment in downtown Mesa for many decades.

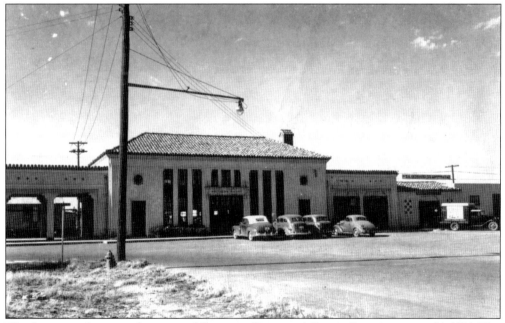

The first train depot at what is now University Drive and Center Street was gone by 1911. The Santa Fe, Prescott, and Phoenix Railroad came into Mesa along Third Avenue, and its depot was built along Third Avenue, between Macdonald and Robson Streets, close to the creameries, mills, and warehouses. The Southern Pacific Railroad took over this railroad in 1925 and built this depot at Third Avenue and Robson Street. As passenger train service declined, this station was abandoned and later burned.

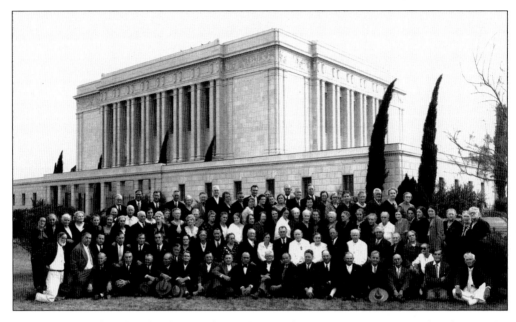

For members of the Church of Jesus Christ of Latter-day Saints, to return to Salt Lake City for marriages and religious services at the temple was the dream of a lifetime. This arduous journey could take weeks by wagon and even in the days of the railroad, the trip could only be made via Denver or San Francisco. Fund-raising and planning for the Arizona temple began around 1911, and the ground breaking was April 23, 1922, with construction beginning the following January. The temple's design was inspired by Solomon's temple in Jerusalem. It was completed in 1927 and dedicated on October 23.

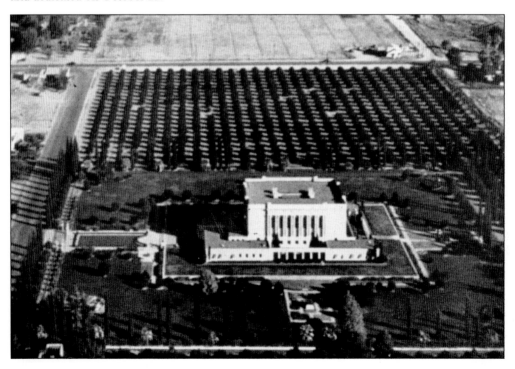

Seven
MESA AND THE GREAT DEPRESSION

The depression caused by the cotton crash in the early 1920s was only a prelude to the Great Depression, which began with the stock market crash in 1929. Throughout the state, profits from agriculture and mining fell drastically over the next few years. Mine towns closed and the shipping industry declined.

The consequences for Mesa were dire because much of what the city produced was shipped beyond the Salt River Valley. Wages fell, stores, banks, and businesses closed, and farms faced foreclosure. Teachers were paid with vouchers, and many merchants discounted them severely before accepting them. The local newspaper, the *Mesa Journal Tribune*, printed its own money to pay its employees after the banks failed. It was known as "Mesa Money" and was accepted at several local stores.

The New Deal programs of the 1930s provided assistance to Mesa and its residents. The Works Progress Administration (WPA) constructed several buildings, installed underground pipes, paved streets, and improved the water system.

The years of economic hardship were difficult for the citizens of Mesa. By the end of the 1930s, federal assistance to Mesa's residents helped to alleviate some of the burdens caused by the Depression. Sadly, it would take an even more tragic global conflict to end it.

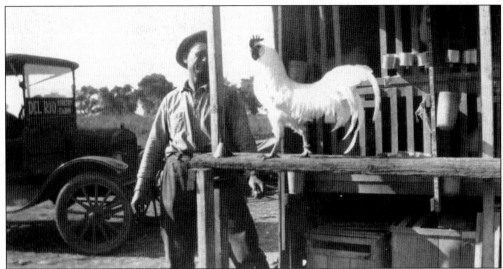

Large-scale poultry operations began to appear in the 1910s and the 1920s in Mesa and Lehi. George Gilbert Haws, pictured with one of his prize roosters, was one of the most prominent of Mesa's early poultry farmers. He established Del Rio Farms in 1919, which became well known for its prize-winning White Leghorns. By the early 1930s, his poultry operation included well over a 1,000 chickens and a huge egg incubator. A leader in poultry farming, Haws served as president of the Arizona Poultry Association.

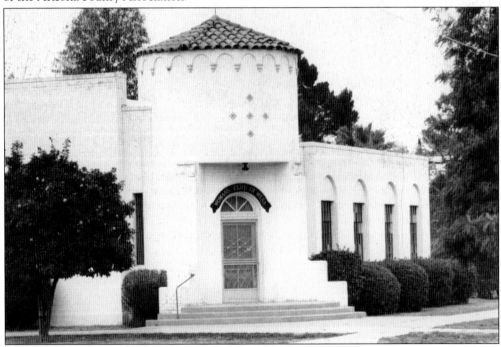

Founded in 1917, the Mesa Women's Club sponsored cultural, civic, and philanthropic activities. Members of the club spearheaded a campaign to cover open irrigation ditches, supported Mesa's first library, raised money for local hospitals and charities, and provided aid to needy families during the Depression. Located on Macdonald Street, the Women's Club building was constructed in 1931 and is listed on the National Register of Historic Places.

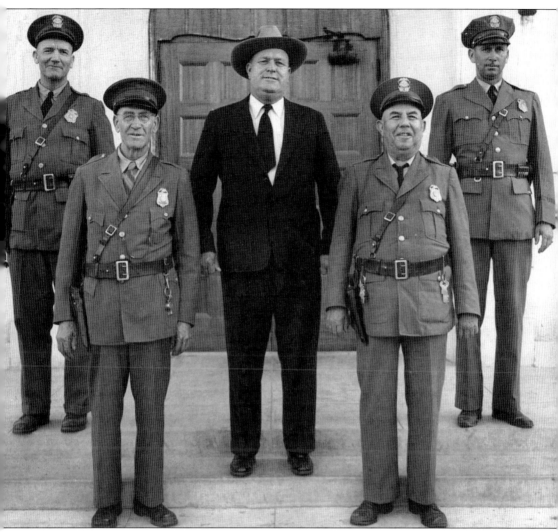

By the early 1930s, Mesa's police department consisted of the police chief and four officers. One of these, Ramon Mendoza, second from right, was Mesa's first Mexican American law enforcement officer. Natives of Sonora, Mexico, Ramon and his wife Delores came to Mesa in 1893 and settled in Lehi. He was hired as a special police officer in 1922 and later became a regular officer, retiring in 1942. He was also the town's first *zanjero*, or water guard. *Saber es poder*, or "knowledge is power," was a family saying as both Ramon and Delores recognized the importance of education and strong family ties. Their children were all successful, including Ramon Mendoza Jr., who later became Mesa's first Hispanic police chief.

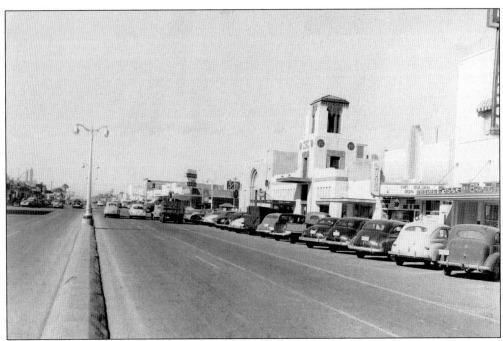

Mesans, like the most other Americans, loved going to the movies, both the early silent movies and the later talking movies. The Ritz Theatre was one of two theaters on Main Street following World War I. It was often frequented by Mexican Americans.

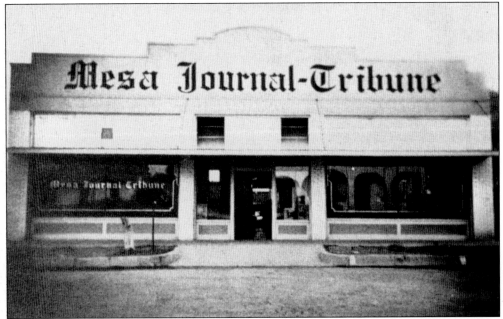

Throughout the Depression, the *Mesa Journal Tribune*, kept residents informed about state and national developments while working in a variety of ways to promote Mesa businesses and help charitable causes. Recognizing that the town needed bolder measures to rebound economically, the newspaper published several editorials calling for a sales tax. Quoting Proverbs, a front-page editorial in May 1933 read, "Where there is no vision, the people perish."

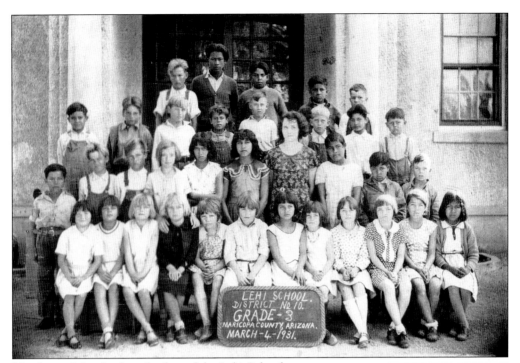

Members of the third-grade class of the Lehi School pose on the school's front steps on March 4, 1931. The Lehi School was not segregated, and Mexican American and Japanese American children attended school there. One graduate of the Lehi School has been immortalized by the words "Carry On," the motto for Mesa High School. Zedo Ishikawa was the first child and only son of Kurataro and Hatsune Ishikawa, Lehi's earliest Japanese family. Zedo was a star football player at Mesa High School and an active Boy Scout. On the evening of September 21, 1932, Zedo was returning home from a Scout meeting when he attempted to separate two fighting dogs by pushing the butt of a gun between them. The gun discharged and the bullet lodged in Zedo's chest. With his last breaths he told his family to tell the coach to go ahead and play the upcoming football game and to "tell the boys to carry on." His memory lives on in countless yearbooks, on scoreboards and banners, and in the school song.

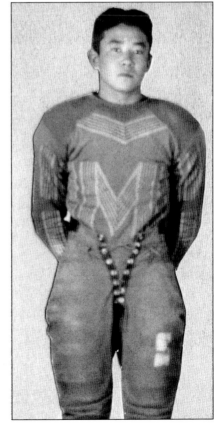

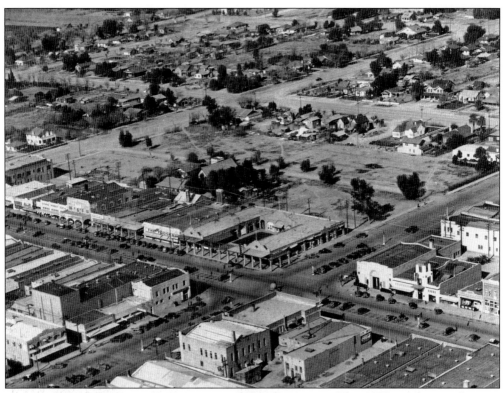

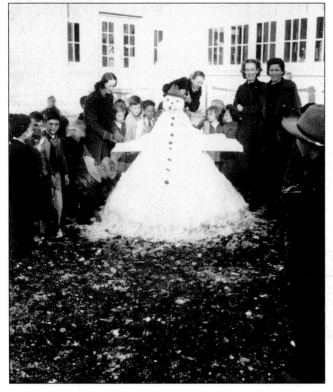

This 1936 aerial view of downtown Mesa shows how much the city had grown beyond its original borders. The courtyard of Chandler Court is clearly visible in the center of the photograph. Valley National Bank is across the street to the right of Chandler Court.

Mesa experienced its largest snowfall ever, as 3 inches of snow fell and the temperature fell to a record low of 21 degrees on January 30, 1937. Snowmen were everywhere, schools closed, and local merchants had a run on cameras and film as Mesans sought to record this rare experience. The snow stayed on the ground for about a week before it melted. This group of students built a snowman on the playground of the Lincoln School.

Iceboxes were still in use during the 1930s. Carl Standage's first job after high school in 1934 was delivering ice for the Diamond Ice Company.

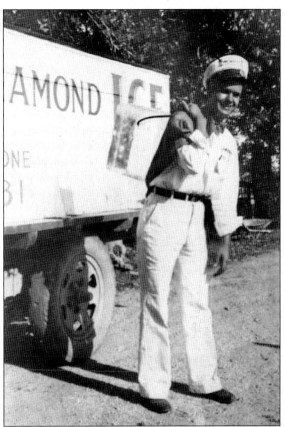

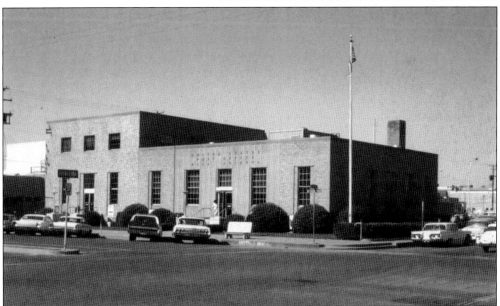

Among the buildings constructed by the WPA in 1937 was the post office located at the corner of Macdonald Street and Pepper Place. Others included a new city hall and police station on Macdonald Street, as well as the Rendezvous swimming pool and the auditorium at the Lehi School.

The modernization of Mesa continued as the WPA completed a multipurpose municipal building at the corner of First and Macdonald Streets. The building, which included the police and fire stations, as well as the city jail and library, forms the core of the Arizona Museum of Natural History, formerly the Mesa Southwest Museum.

Another WPA project was the construction of the new Southside Hospital. This modern, up-to-date hospital replaced the original six-bed Southside Hospital opened by Dr. Palmer in 1912.

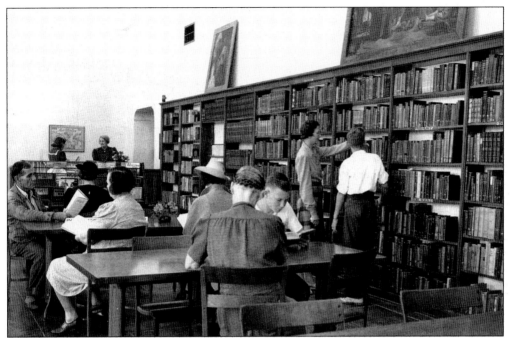

Originally opened in 1906 as a free reading room, Mesa's public library was housed in a series of commercial buildings in the downtown area and was staffed by volunteers. The city took over management of the library in 1926. The library moved into the newly constructed city hall in 1937, its first permanent home. Today this room is the theater for the Arizona Museum of Natural History.

Another federal program, the Federal Housing Administration (FHA) encouraged Mesa residents to become homeowners through low-cost federal loans. In 1936, the FHA built a demonstration home in Mesa to show families that they could buy their own home for as little as $50 a month, compared to paying $30 a month to rent a run-down local property. This house became known as "the Mitten House," after the first family to move in. Mitten was publisher of the *Mesa Journal Tribune* at the time. This is a later photograph of the house.

The city's park department was established in 1936, and Mesa residents dedicated their first city park, Rendezvous Park, in May 1938. It featured a skating rink, tennis courts, a swimming pool later rebuilt by the WPA, bathhouse, and a floodlit baseball field. Located at Center and Second Streets on the site of the former Depot Park, the park had been built by volunteers over a number of years. The baseball field was the first to be built, in 1920, and was home to the city's semi-pro teams for decades. The field was used for major league spring-training games, including the Chicago Cubs and the New York Giants.

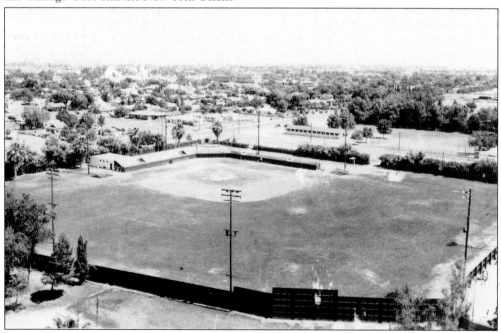

Eight
WORLD WAR II AND MESA

On December 7, 1941, Mesa residents gathered around their radios to hear the breaking news that the Japanese had bombed Pearl Harbor. The United States was at war. World War II shook the foundations of Mesa's small rural community. Residents felt the effects of the war almost immediately, as fathers, sons, and husbands enlisted or were drafted into the military.

Rationing hit Mesa as it did elsewhere in the country, though Mesa had an abundance of agriculture to help support the community. For the war effort, the government rationed access to rubber, gas, sugar, metal, and paper. Clothing was rationed, as cloth became scarce. There was such a dearth of paper that residents rarely saw toilet and tissue paper during the war.

Although the people of Mesa faced rationing and other wartime restrictions, the local economy showed signs of recovery from the Great Depression. Feeding and clothing the millions of service personnel involved in the war required an enormous amount of food, cotton, and wool. Agricultural industries boomed during the war years as Mesa's farmers worked to produce enough crops for local and national needs.

The thousands of airmen stationed at Falcon and Williams Fields impacted the local scene in other ways as well. The sudden influx of servicemen and the rationing of goods and services strained the housing market. Housing was so scarce that the federal government built housing projects like Escobedo to help alleviate the shortage.

While American and British soldiers trained to defend democracy abroad, decisions made in the name of the war effort took away the rights of some citizens at home. The war brought to the surface issues of prejudice and mistrust against Americans of certain ancestry. None were more affected than Japanese Americans when President Roosevelt singled out American citizens of Japanese ancestry as potential enemies of the state. An executive order issued in February 1942 required Japanese Americans on the West Coast to leave their homes. Many were sent to relocation camps in Arizona.

By the end of World War II, in 1945, Mesa citizens had experienced loss, hardship, and prejudice. Mesa was justifiably proud of its contribution to the war but was happy to move into a peaceful postwar era.

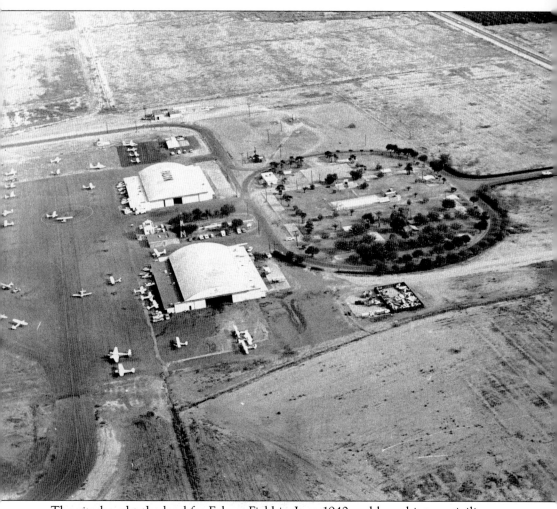

The city bought the land for Falcon Field in June 1940 and leased it to a civilian company, Southwest Airways, to build and operate the No. 4 British Flying and Training School. The field occupies one square mile in northeast Mesa at what is now Greenfield and McKellips Roads. The first 150 British Royal Air Force (RAF) cadets arrived at Falcon Field in early 1940. The airfield was named after the bird of prey that has historically represented the courageous spirit of the British people. Because America was still officially a neutral country, the airmen could not wear their uniforms off the base. More than 2,000 cadets, the majority of which were British, trained at the base during the war. Chinese and American pilots also trained at Falcon Field because of the additional navigational training provided. The cadets spent 300,000 hours in the air and flew more than 45 million miles. Twenty-four RAF cadets, one American pilot, and three instructors were killed during training. The British cadets are buried at the Mesa City Cemetery.

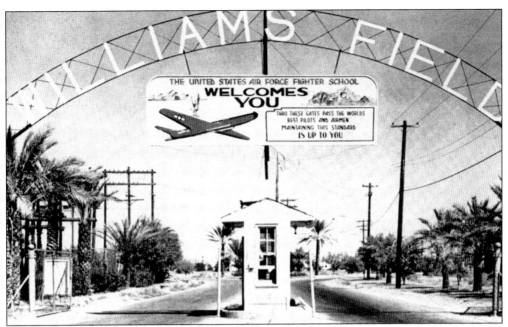

In early 1941, the U.S. Army Air Corps announced plans to build an airbase on 3,700 acres of land south of Mesa. Named in honor of Arizonan Lt. Charles L. Williams, who died in a plane crash during combat in World War I, construction of the base began in the summer of 1941. By the time of the attack on Pearl Harbor in December 1941, Williams Field was the home of the Air Corps Advanced Flying School. Williams Field was an ideal location to meet the urgent need to train pilots for overseas combat. This flight training was offered to American, British, and Chinese pilots, and the flags of all three nations were flown on the base. By the time the war ended, more than 4,000 airmen had been trained at Williams Field, and it remained the largest fighter pilot training school in the world until the base was officially closed on September 30, 1993.

The citizens of Mesa went out of their way to make the British airmen feel welcome. Many local residents opened their homes to the servicemen. Host families "adopted" British pilots. A hospitality house opened during the war and provided much-needed comfort for the cadets who were far from home. On base at Falcon Field, this soda fountain was a popular spot for them to relax.

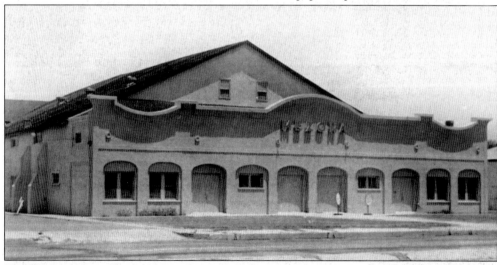

The Mezona, originally the Vance Opera House, was the social hub of Mesa for decades. Friday night dances were the highlight of the week, and nearly every eligible girl in town could be seen there in their finery. During the war, British airmen training at Falcon Field and Williams Field were welcomed at the Mezona. Another appeal of the Mezona was its unique air conditioning system. Water was pumped over three 100-pound blocks of ice, radiating a cooling effect throughout the building.

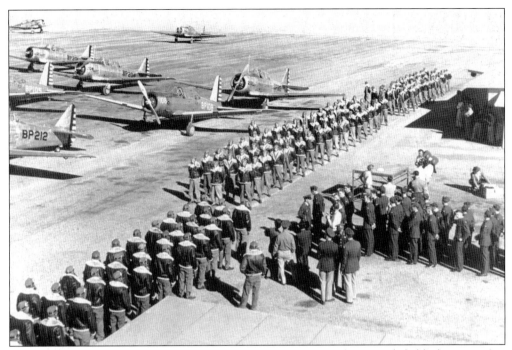

Along both the East and West Coasts of the United States, mandatory nightly blackouts were in effect to guard against enemy bomb attacks. Many movie studios moved their filming to Arizona, where there were no blackouts, allowing nighttime filming. These Chinese and British cadets were part of the filming of *The Thunderbirds* at Falcon Field in 1942.

In March 1942, the Mesa City Council appointed a war council to protect Mesa from air raids. The city purchased a large air-raid siren and announced daily drills. Mesa city government, fearful that the water supply could be sabotaged with biological agents, added chlorine to the drinking water. Military personnel from Falcon Field and Williams Field also helped keep the peace in Mesa throughout the war.

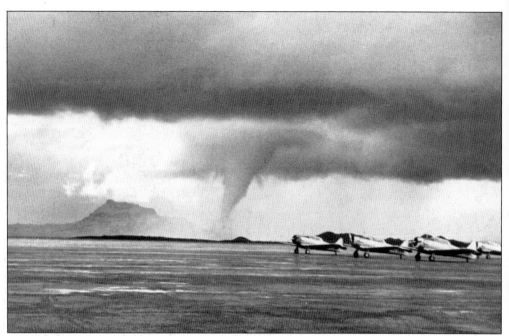

Located in the Sonoran Desert, Mesa is known for its sunshine and blue skies. However, during the summer months, monsoons can produce violent storms. This rare funnel cloud was photographed approaching a row of AT-6 aircraft at Falcon Field during the war years, although no damage was done. Red Mountain can be seen in the background.

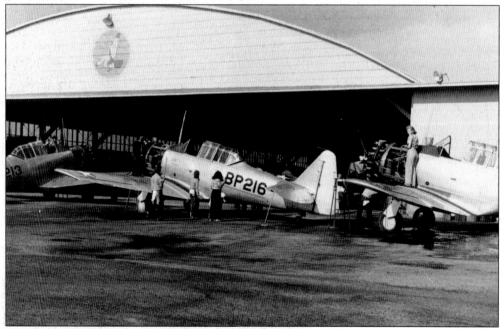

Mesa had their own "Rosie the Riveters," as the women in the area learned to maintain and repair the aircraft used to train the pilots during the war. Employed at both Falcon Field and Williams Field, this women's maintenance crew was hard at work at Falcon Field in the early years of World War II.

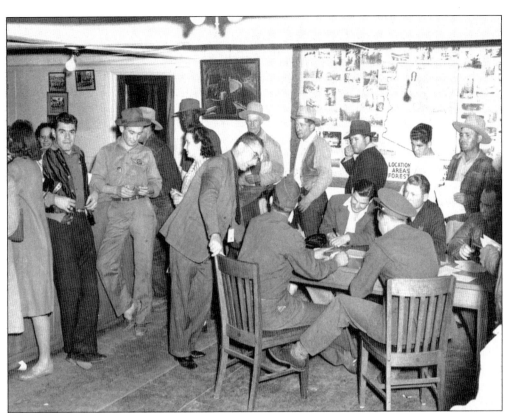

Everybody in Mesa contributed to the war effort—rationing, collecting, and donating whatever he or she could spare. Residents collected scrap metal, and housewives saved tin cans and collected cooking fat. People of all ages learned to give first aid and to respond to air-raid sirens. War bonds raised money for the cause, and people sacrificed whatever they could to support the war effort. While fathers and sons filled the army recruitment offices, the women of the community pitched in by rolling bandages.

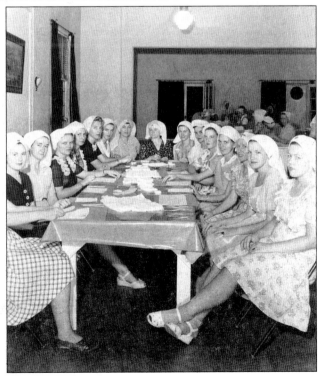

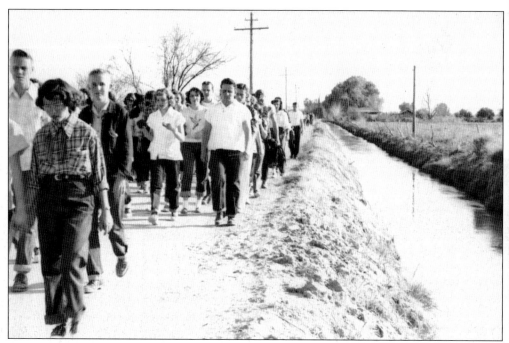

Long staple cotton was especially important to the war effort. For the war in the air, the need for parachutes was as critical as the need for food. Long staple cotton was needed to make parachute rope, uniforms, and other essential military equipment. Students, such as these from the Franklin School, learned to pick cotton in the absence of the men away at war.

Sheep, such as these crossing a bridge over the Salt River, were also an important agricultural product during World War II. Both the wool, used for uniforms, and the meat were needed to help keep the vast armies overseas supplied.

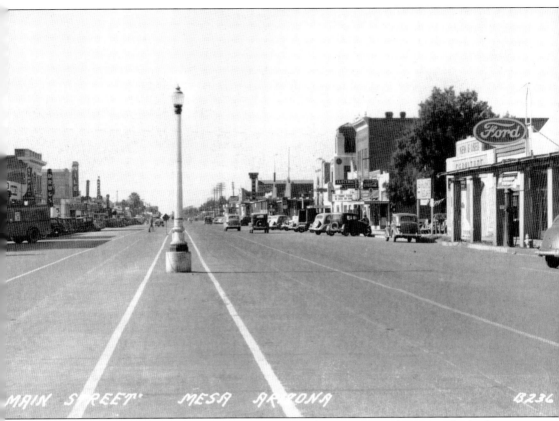

The executive order signed by the president of the United States required anyone who had just one great-grandparent of Japanese ancestry to leave their homes and possessions, and relocate to government internment camps. Two of these camps were in Arizona and held Japanese Americans from throughout the West, including those who lived south of an imaginary line drawn across the state. The imaginary line dividing Arizona went right down Main Street in Mesa. Japanese Americans living south of the line were forced to move in with family or friends or face relocation to an internment camp. Those who lived on the north side of the line were suddenly cut off from the rest of the town, including Southside Hospital, Mesa High School, much of the shopping and the train depot. Many people in Mesa felt compassion for their Japanese American neighbors and helped them secure needed goods, get agricultural products to market, and receive vital services, such as medical care. Although there were a few unfounded rumors that the Japanese Americans were trying to aid the enemy, most people had sympathy for their fellow citizens during the difficult war years.

The El Portal Hotel opened in 1928. Financed by the sale of stock to Mesa residents, it was meant to compete with Chandler's famous San Marcos Hotel. Soon after the hotel's opening, the onset of the Great Depression in 1929 severely impacted the hotel business and the El Portal soon floundered. The hotel closed for several years but occasionally was used as a location for filming movies during that time. The hotel eventually reopened, and by the end of World War II, it had recovered its former glory. It was a popular place for dining out. In this photograph dated May 10, 1946, less than a year after the end of World War II, Japanese Americans were again taking part in the social life in Mesa. Janet Ikeda is pictured in the center of the photograph, and her husband, Tom Ikeda, has his back to the camera. Tom was involved with the chamber of commerce for many years and was also general chairman of the Rawhide Roundup. (Courtesy Steve Ikeda.)

Nine
THE BOOM YEARS

Following World War II, the economy of Mesa underwent a profound change. As the country demobilized and began to return to a sense of normalcy, a series of changes began that would transform Mesa from a rural farming community into a city of close to a half a million people.

Farming, which had been the backbone of Mesa's economy, was becoming less important as mechanization both increased production and decreased the need for human labor. The value of farming commodities dropped as overproduction continued and the value of farmland decreased. With few exceptions, mechanization reduced the numbers of workers needed to perform most types of agricultural work.

The population of Mesa and the Valley began to swell as soldiers who had been stationed there during the war decided to settle here. The new cold war defense industries brought both new jobs and new residents to fill those jobs. The mass production of affordable air-conditioning units in the 1950s made year-round living in the desert bearable.

The decline of traditional agriculture was accompanied by the diversification of other businesses. Such industries as construction, defense, and tourism began to displace agriculture as the main basis of the local economy. The disappearance of farmlands, pastures, and orchards accelerated, as demand increased for shopping centers, motels, and housing developments.

The tourism industry came into its own after World War II. By the late 1940s, the chamber of commerce was actively promoting the advantages of the area. The Old West was a popular cultural trend on which Mesa capitalized. Attractions such as dude ranches, motor courts, and Old West–themed events brought tourists and their dollars to Mesa. Conventions were held in Mesa, and hotels, parks, museums, and amphitheaters were built to serve the tourist industry.

Over the next three decades, the city continued to grow and prosper. Jobs in the high-tech, tourist, and service industries boomed. Automobile travel was a popular way to vacation, and related industries, such as gas stations and automobile-repair shops, increased in number.

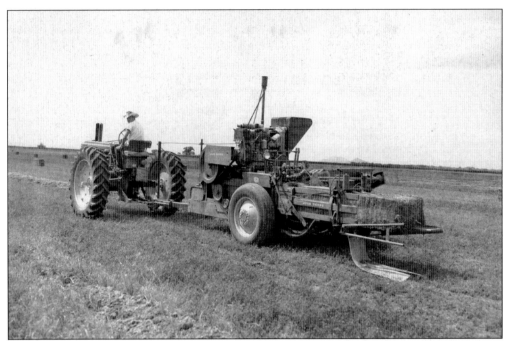

Agriculture and its support industries provided the economic base for Mesa before 1950. This began to change in the postwar years for a variety of reasons. Mechanization of farm equipment meant more could be done with less manpower. The wartime expansion of industries, especially those geared toward heavy equipment, combined with technological innovation sparked a revolution in farm machinery that would profoundly change the face of farming across the country. Factories that had produced tanks, trucks, and other heavy vehicles for the war effort now began to manufacture tractors, combines, cotton pickers, and other specialized farm machines. Tractors slowly but steadily pushed horses and mules off the farm.

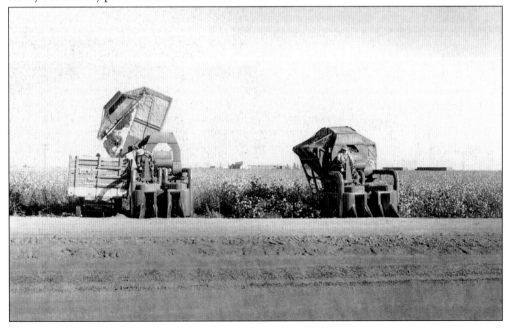

Mechanical air-conditioning units had existed for homes and businesses since the 1930s but were expensive and not widely available. Combined with the cost of electricity to run the units, air-conditioning remained a luxury for the most part. Mass production of units began in the early 1950s and made air-conditioning more affordable for the middle class. By the end of the decade, most residents and visitors enjoyed the cool air that air-conditioning provided. What had been a luxury became a necessity.

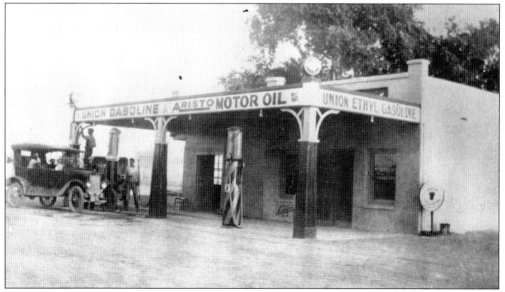

This gas station, located at the southwest corner of Main Street and Mesa Drive, provided gasoline and automotive services to the motoring public.

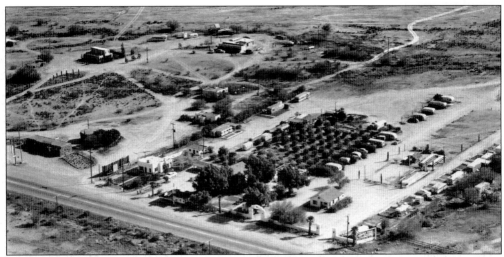

Perhaps the person who most recognized Mesa's appeal was the showman Mark Barker, an eastern greenhorn who dreamed of being a cowboy and living the outdoor life in the Southwest. Also known as "Moxo the Magician," in the 1930s Barker was an aspiring young entertainer with a growing national reputation. He toured the West frequently. On one of these tours, in 1938, Barker spent the night in Mesa and fell in love with the area. He soon returned, bought the motel where he stayed, and converted it into the area's first trailer park—the first commercial venture of its kind in the state. Sunset Trailer Ranch launched an industry for which Mesa became famous. However, Barker's true talents were in promotion and entertainment. Among his other ventures was a popular 1950s radio show called *Luncheon in Mesa* on KTYL. These guests are wearing homemade hats featuring Arizona's Historical Five C's: copper, cotton, cattle, citrus, and climate.

Capitalizing on the popularity of the Old West theme, the Mesa Jaycees launched their hugely popular Rawhide Roundup Old West Festival in 1947. An entire Old West town was built on Center Street just north of Main Street. The town featured saloon girls and outlaw desperados portrayed by local residents. These young women, members of Gamma Phi Beta Society at Arizona State University, were performing during the *Rawhide Follies*.

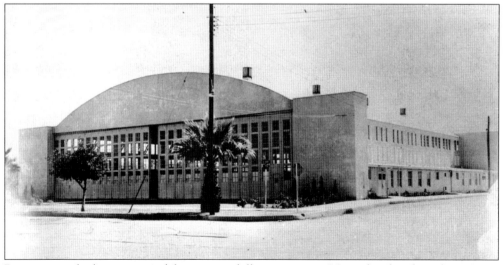

Recognizing the huge potential for tourism dollars coming to Mesa, the chamber of commerce encouraged the city to buy a vacant aircraft hangar at the Marana Airfield near Tucson for $56,000. The city purchased the building in 1947 and moved it to Mesa, where it was renamed the Mesa Civic Center. It was the largest municipally owned convention center in the state and the site of many major conventions and meetings, including the Maricopa County Fair. The building burned to the ground in 1959.

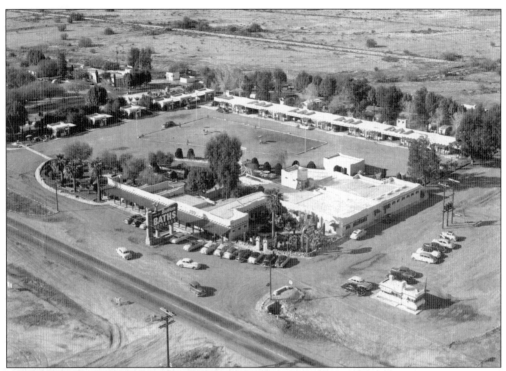

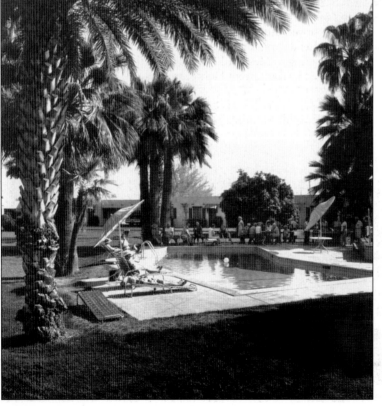

Built at the site of mineral wells discovered in 1939 by Ted and Alice Sliger, the Buckhorn Baths Motel on Main Street on the eastern edge of Mesa was a popular tourist destination for many years. These wells became known for the relief of arthritis, neuritis, and rheumatic problems. The Chicago Cubs and the New York Giants used the wells for conditioning during spring training, while many Hollywood celebrities frequented the hotel year-round.

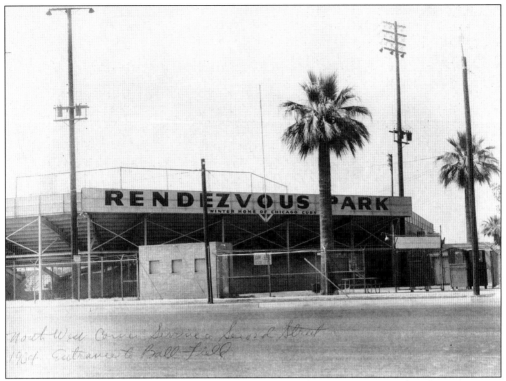

Professional baseball came to Mesa in 1952, when the Chicago Cubs began to use Rendezvous Park as their spring home. They stayed until 1965, when the team moved to Scottsdale. The Oakland Athletics trained first at Rendezvous Park, then at the new Hohokam Park for the 1977 and 1978 seasons. The Cubs, returning to Mesa in 1979, played at the original stadium until it was torn down in 1997 and replaced by the current Hohokam Stadium.

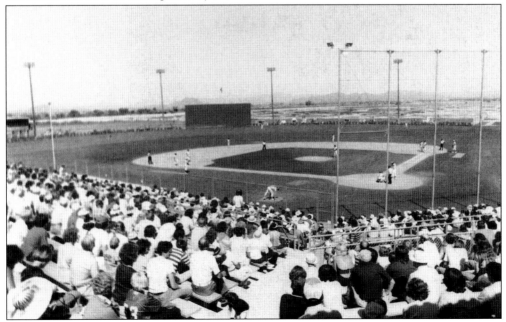

Mesa, like other communities in America through the mid-20th century, experienced forms of segregation. Many public facilities, such as the pool at Rendezvous Park, were segregated, and there were separate colored and white restrooms at city hall. In 1953, a group of Mesa's citizens organized the Better Community Council (BCC) to fight racial discrimination. The BCC lobbied Mesa's restaurants and hotels to sign anti-discrimination pledges. This group also led an effort to open the Rendezvous Park swimming pool to minorities. At this time, African Americans could not use the pool, and this policy may have extended to other minorities. The BCC took a poll of members of civic organizations asking if "the current policy of banning Negroes from public swimming should be maintained?" While some favored full desegregation of the pool, and others wanted the ban to stay in effect, the majority favored opening the pool one or two mornings a week for minorities. Thereafter, in what was seen as a progressive move, minorities could use the pool on Wednesdays and Saturdays, days when the pool was later drained.

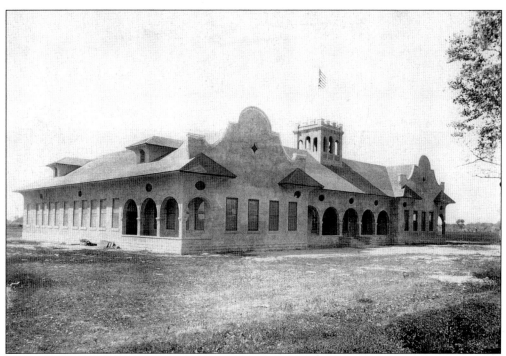

In the early days of the town, all students could attend any Mesa school. This began to change in the 1910s, as the minority population began to grow. Daniel Webster School, built in 1911, originally taught only children of Mexican descent. As the African American population increased, their children at first attended the Webster school as well. The Webster school separated African American and Mexican American children into different classrooms. African American children attended Booker T. Washington School after it opened in 1920. Mesa Junior High and Mesa High School were never segregated. Mesa had already begun to integrate its schools years before the U.S. Supreme Court ruled that segregated schools were unconstitutional in 1954.

The Booker T. Washington School opened in 1920 as a segregated school for African American children. Veora Johnson, seen here teaching at the school, became the first African American administrator in Arizona and the first black principal in the Mesa School System. She also served as the curriculum consultant and primary education consultant for the city. Active in the civic life of the community, she won numerous awards, including Mesa's Citizen of the Year and inclusion in The World's Who's Who of Women. After retiring in 1974, Johnson was honored by the naming of Veora Johnson Elementary School in Mesa.

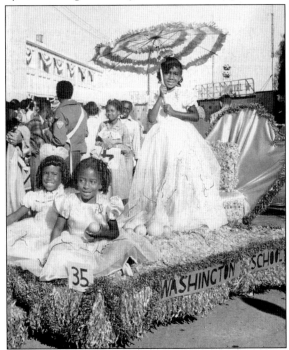

The Miniature Citrus Parade, first held in Mesa in 1934, was an institution in Mesa for decades. After the parade, the floats were put on display at the civic center after it opened in 1948. These young girls are shown on the Washington School's float in the 1952 parade.

Mesa Union High School, built in 1908, was Mesa's only high school for nearly 60 years. The high school was a centerpiece of the community and a gathering place for the citizens of Mesa. The community was devastated when the school burned in 1967. Even today, the alumni of "Old Main," as it was known, remain faithful to its spirit and traditions.

The Mesa High School Rabbettes was a marching squad of young women, with marchers, ropers, and twirlers under the direction of Marjorie Entz. The Rabbettes performed at football games, parades in both Mesa and Phoenix, and the Rose Bowl Parade. The Rabbettes disbanded after Entz's retirement.

Before 1954, Main Street had been the commercial and retail hub of Mesa. As the city grew and automobiles became more commonplace, shopping began to move away from Main Street and from the center of town.

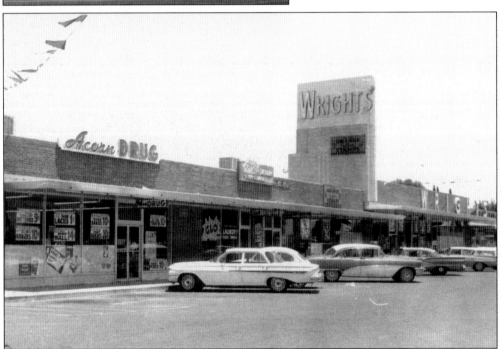

The first modern shopping center with an off-street parking lot opened in 1954 at the corner of Fourth Avenue (now Broadway) and Mesa Drive. Wright's Grocery Store anchored the first shopping center outside the original city center. It also included an Acorn Drug and eight other stores.

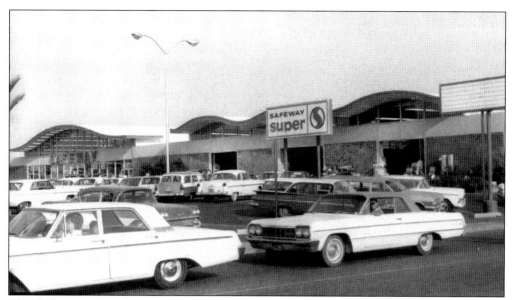

This Safeway, pictured in 1965, was located at the corner of Main and Horne Street. It was one of the first national chains to locate in Mesa and begin competing with local grocers.

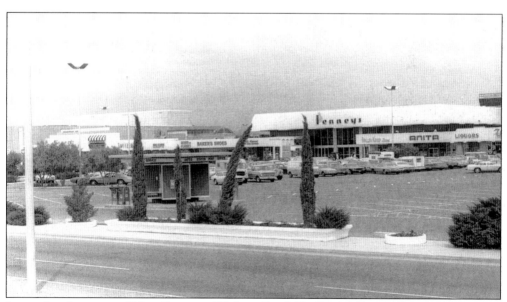

Located at the corner of Main Street and Dobson Road, Tri City Mall opened in 1968. It was the first indoor mall in the East Valley. Now closed, the site of the mall will be the location of Mesa's Light Rail, which will tie Mesa to Tempe, Phoenix, and other points in the valley by train.

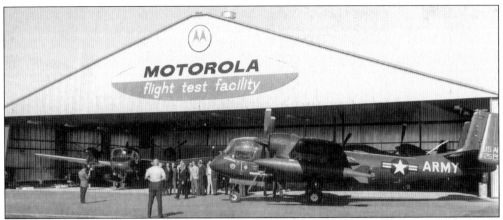

The cold war was instrumental in bringing new defense-industry manufacturing jobs to Mesa beginning in the late 1950s. Motorola opened this plant at Broadway and Dobson Roads in 1966. It closed in 2003. Honeywell, Boeing, General Dynamics, Semiflex and Hughes Helicopter were among the many companies to bring high-tech jobs to the area.

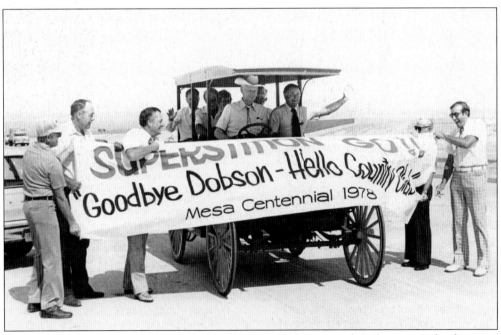

Expansion of the freeway system in the East Valley spurred Mesa's growth and economic development. The Superstition Freeway was the first freeway to reach Mesa, at Dobson Road in 1977. Extending eastward during the 1970s, the Superstition Freeway opened a corridor that provided unprecedented ease of access. This section, from Dobson Road to Country Club Drive, opened in 1978, Mesa's centennial year. Mayor Wayne Pomeroy can be seen in the passenger seat.

Cliff Dobson, along with his brother-in-law, Dwight Patterson, owned an enormous empire of sheep and cattle along Baseline Road until the late 1960s. As development crept closer, they began to sell off portions of their property along its northern edge. Their empire, like the rest of the livestock industry around Lehi and Mesa, began to disappear in response to the increasing pressure of urban and residential growth. By the late 1960s and the 1970s, the demand for houses and services overtook the need for agricultural land. Although other postwar communities had been developed, Dobson Ranch was the first major agricultural land to become a planned community. It included a golf course, artificial lakes, and a homeowners' association.

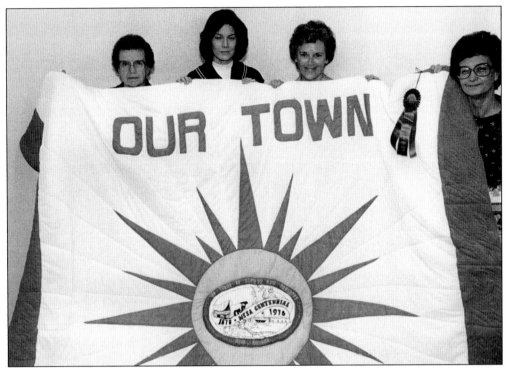

Mesa celebrated its centennial in 1978. In those 100 years, the city grew from a small agricultural settlement of a couple of hundred people to a major city whose economy became based on the high-tech industry and tourism. The city held parades and put up billboards to honor the 100th birthday of the city. These women are holding a quilt with the city's centennial logo, designed to honor its pioneer past, while showing Mesa looking confidently toward the future.

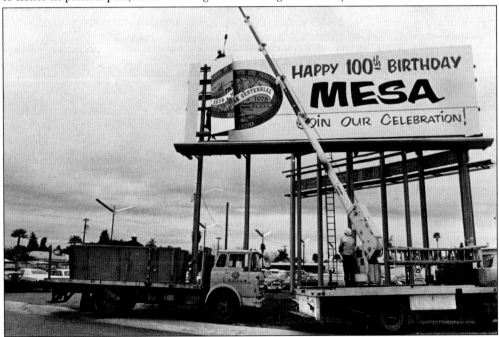

Ten

BUILDING ON THE PAST TO CREATE THE FUTURE

Mesa has experienced great population spurts, doubling its population every decade between 1930 and 1990—making it one of the fastest-growing cities in the country with populations of over 100,000. By 2020, Maricopa County, where Mesa is located, will have a population of nearly 5 million, double its population in 2000. Mesa's housing capability, when available vacant construction space within the city's boundaries is full, will be about 680,000 people. Although there are still some citrus groves and some field agriculture in Mesa, the city has mostly left its agricultural roots behind. Today Mesa strives to build a diverse modern economy based upon high technology, aviation, construction, health care, tourism, and service industries.

Nationally, tourism is a growth industry of the future. The economic impact of tourism continues to increase. By 1990, the service industry, representing only a portion of the tourist trade, accounted for nearly a quarter of Mesa's economy.

To continue to participate in the growing tourism industry, Mesa must continue to cultivate its sense of place by preserving its historic neighborhoods, supporting its museums, and highlighting the arts, including the New Mesa Arts Center. All great cities in the world have institutions that are devoted to arts, culture, and history and that express the flavor of the city, preserve sites and objects of its heritage, and offer citizens the opportunity to better understand the community and their place in it.

Mesa is home to a thriving arts and cultural community that enriches the lives of the valley's citizens. For theatergoers, the city is home to East Valley Children's Theatre, Mesa Encore Theatre, and the Southwest Shakespeare Company. The Mesa Symphony Orchestra, Ballet Etudes, Metropolitan Youth Symphony, and the Sonoran Desert Chorale provide valley residents music and dance performances. Xicanindio Artes, Inc., supports the arts of indigenous and Latino peoples.

Mesa today is a diverse city, as it has been since the early days of the 20th century. Although the perception is that Mesa is a Mormon community, they only account for about 10 percent of the population.

Winter visitors constitute the largest group of tourists and come to Mesa from all over the country and Canada between October and April to enjoy the warm climate. Winter visitors, or "snowbirds," as they are affectionately known, enjoy local venues, golf, Mesa's close proximity to other valley and state destinations, and the biggest attraction of all: baseball spring training. Pictured is a tour-bus group in 1972.

One of the most popular destinations for tourists, especially winter visitors and Chicago Cub fans, is Hohokam Park, where the Cubs play spring ball. This modern stadium was built in 1997 and can accommodate 12,623 baseball fans. Hohokam Park is also the home of the Arizona Rookie League Mesa Cubs and the Solar Sox of the Arizona Fall League.

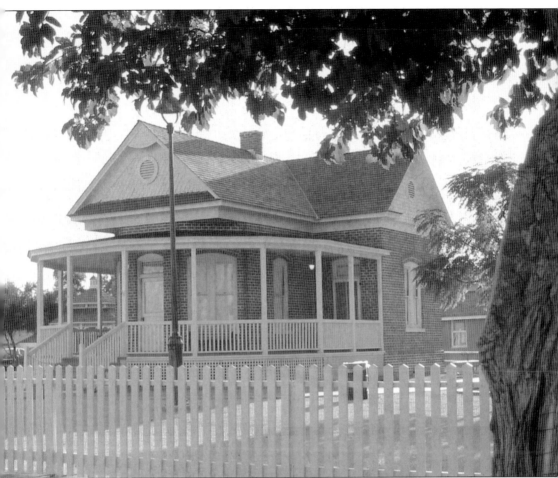

The Sirrine House is a good example of historic preservation in the city. Joel Sirrine built the house in 1895 for his new bride, Caroline Simpkins. Joel was the son of George Sirrine, one of the Founding Fathers of Mesa, and came to Mesa as a child with the Mesa Company. A Queen Anne Victorian, his house is one of the few remaining original brick houses in Mesa. Over the years, extra bedrooms, a bathroom, and a more modern kitchen had been added. It eventually fell into disrepair. The city bought the Sirrine House in 1980, and volunteers from the then Mesa Southwest Museum restored it. Opened to the public in 1986, it was run as a historic house museum by the Mesa Southwest Museum. The Sirrine House has been the site of many celebrations in Mesa, including Territorial Days and A Victorian Christmas.

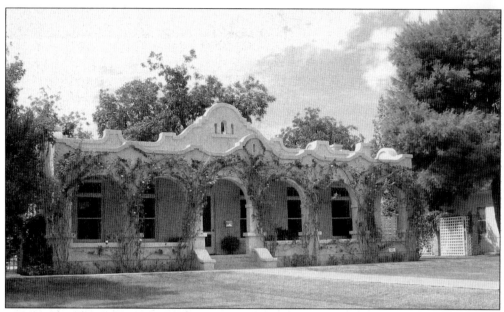

Mesa has a rich tradition of residential communities displaying diverse architecture and history. From its earliest development throughout the post–World War II boom years, Mesa's residential communities have kept pace with the rest of the country by embracing many styles of architecture. Virtually all development eras and architectural styles can be found within Mesa's original square-mile town site. Early residential communities have become a rich historic source for the city. Since 1994, Mesa has identified six historic districts defined as areas that possess a significant concentration, linkage, or continuity of sites, buildings, or structures that are united historically or aesthetically by plan or physical development. Pride in neighborhood, increased property values, and maintaining a community resource are some of the benefits associated with historic designation. These two homes, in the West Second Street Historic District, are good examples of the types of homes found in early Mesa.

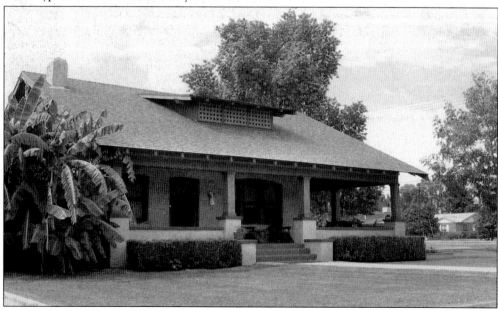

Today's Mesa Police Department is a thoroughly modern force, made up of over 800 sworn police officers and almost 500 civilian personnel. It has all the capabilities of an urban police force, including tactical teams, DUI enforcement, K-9 and gang units, educational programs, community relations, school officers, helicopter units, undercover functions, motorcycle units, and forensics.

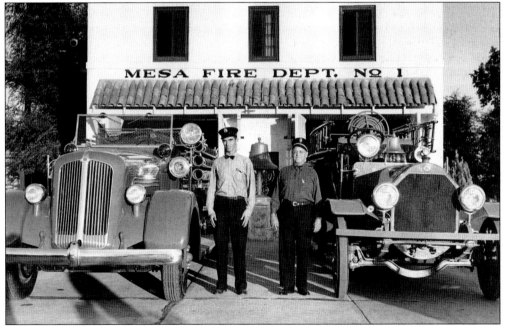

Mesa's Fire Department has grown to meet the needs of a modern city. For the first 20 years, Mesa had no major fires. The first major fire was in 1898, and over the next decade, sporadic fires broke out along Main Street, raising the need for an organized fire department. The fire department was organized in 1919, and the first fire station was built in the early 1900s. In 2007, there are 470 firefighters and 17 fire stations.

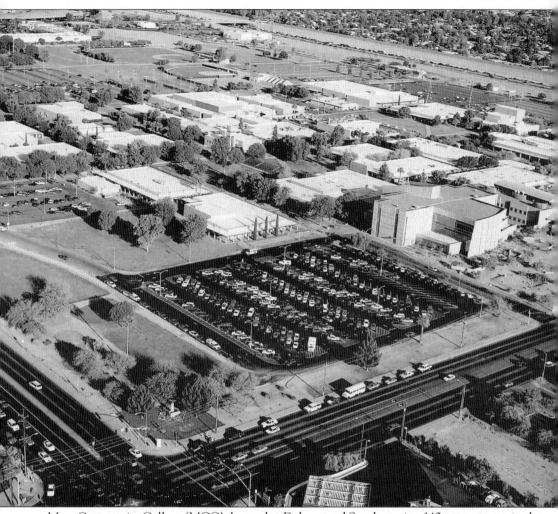

Mesa Community College (MCC), located at Dobson and Southern, is a 140-acre campus in the Maricopa Community College System. Established in Mesa in 1963 as an extension of Phoenix, the campus was originally in the old LDS Alma Ward church, now the Landmark Restaurant. That year, there were 615 students and 20 instructors. It was renamed Mesa Community College in 1966 to encourage local residents to identify the campus as their own. That same year, the school moved to its current location, and had three classrooms for about 2,000 students. Major expansions to the school have occurred in every decade, and enrollment has risen to almost 27,000. MCC has two comprehensive campuses, at Southern Avenue and Dobson Road and at Red Mountain at McKellips Road just east of Power Road. Classes are also offered through MCC's extended campus locations at Country Club Drive and Brown Road and in downtown Mesa on North Centennial Way. Plans are under way to establish an MCC Downtown Campus in collaboration with the city.

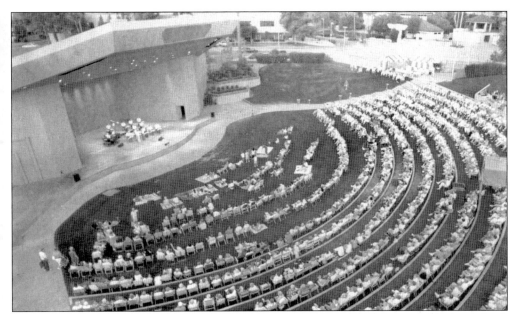

Mesa's amphitheater, famous for its tiered lawn and great location in downtown Mesa, was built in the 1950s. The amphitheatre is intimate enough for all concertgoers to have a great view of the stage and is large enough to host great acts. Drawing from a potential audience of 3 million throughout the valley, it still hosts a variety of performances every year, from Shakespeare to rock concerts.

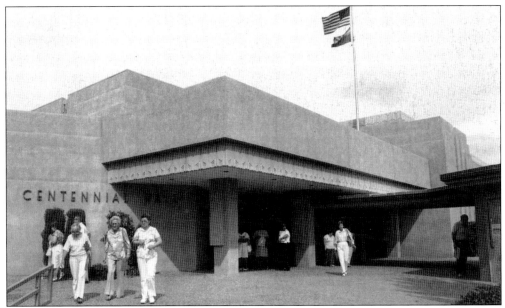

Located in the heart of Mesa on 22 acres of parkland that was the old Rendezvous Park, Centennial Hall is a full service convention and meeting facility with over 38,000 square feet of meeting and exhibit space. The old civic center, which burned in 1959, had been the site of the Maricopa County Fair and the Citrus Miniature Parade. The city needed a new facility to host major events. Centennial Hall was built in the 1970s on the site of the old civic center and was named for Mesa's Centennial Celebration.

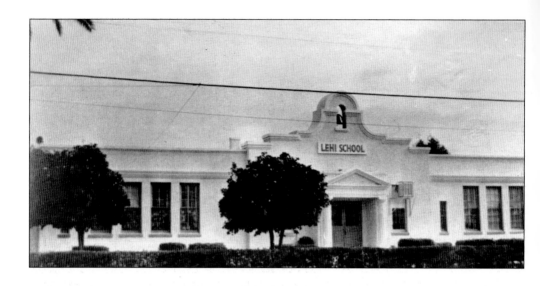

The Mesa Historical Society was formed in 1966 and was instrumental in promoting the preservation of historical sites throughout the city. Today the Mesa Historical Society is housed at the Mesa Historical Museum in a 1914 school located in the Lehi section of Mesa. The museum continues to strive to preserve Mesa's history by collecting objects and photographs, by exhibiting Mesa's history, and by serving as an advocate for the presentation of local history.

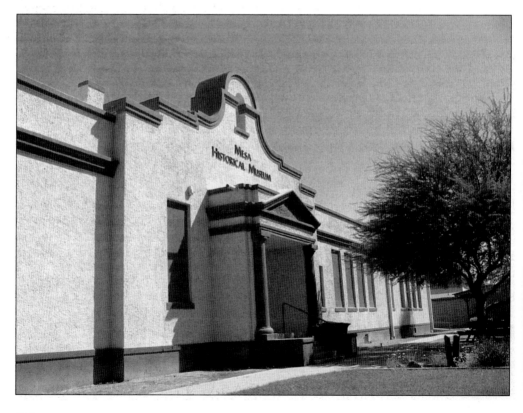

The Arizona Museum of Natural History began as small displays in city hall in 1977 and was called the Mesa Museum of Archaeology and History. In 1985, it changed its name to Mesa Southwest Museum. Over the 30 years of the museum's existence, its mission evolved strongly toward natural history, and in 2007, the Mesa City Council changed the name to the Arizona Museum of Natural History to reflect the museum's dedication to inspire wonder, understanding, and respect for the natural and cultural history of the Southwest. Visitors to the museum experience the last 300 million years of Arizona's natural history, including a strong component of dinosaurs. The museum supports active research programs in archaeology and paleontology, strongly backed by volunteers in the Southwest Archaeology Team (SWAT) and Southwest Paleontology Society (SPS). The museum includes Mesa Grande, the prehistoric Hohokam platform mound site, and the Sirrine House.

In the 1970s, the city offered 24 classes in the visual arts in a facility called the "Art Barn." In 1980, the program was moved to the old Irving School on Center Street, and Mesa's cultural programs were born. The program provided classes to celebrate the wealth of Arizona traditions, including painting, pottery, jewelry making, drama, and dance. The Mesa Art Center, or MAC, also staged the original Mesa Youth Theatre plays, presented free concerts, curated art exhibits, and developed the award-winning Summer Arts Program.

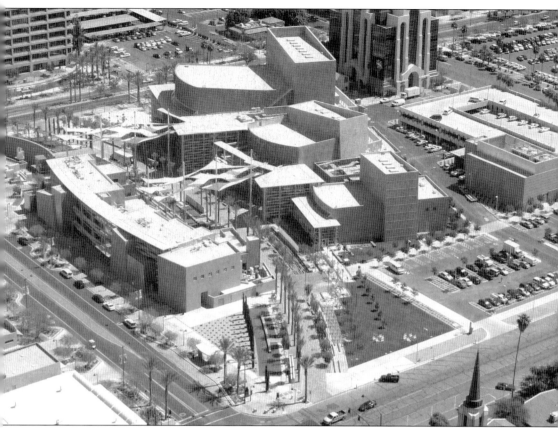

As Mesa and its cultural programming thrived, the Mesa Arts Center soon outgrew it facilities, and plans were made to build a new center. In 1996, the city passed a $4.4 million bond to replace the old arts center, and after a careful feasibility study, voters passed a "quality of life" sales tax in 1998 to cover the capital costs of building a new Arts Center. This sales tax also supplemented the police, fire, library, and public transportation. The new $94 million Mesa Arts Center opened in 2005. It is a 212,755-square-foot performing arts, visual arts, and arts-education facility—the largest and most comprehensive of its kind in Arizona. The spectacular Mesa Arts Center is the product of community grassroots efforts, business and government cooperation, and a deep desire to provide the arts with a vibrant and secure home for generations to come.

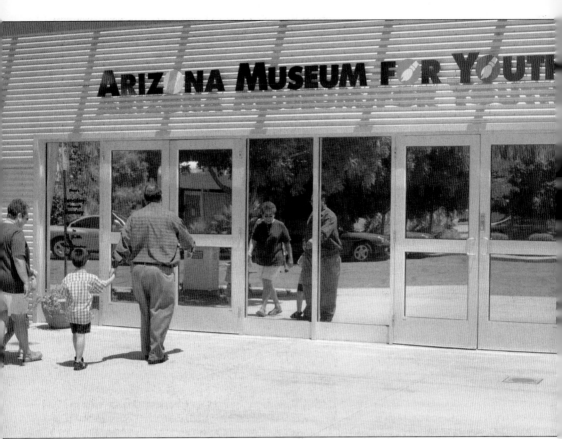

The internationally renowned Arizona Museum for Youth began as the dream of founder Jack Whiteman in 1976. He wanted to "build an arts facility which does not duplicate any existing arts facilities." The museum obtained nonprofit status in 1978, and in 1980, became the only children's museum with a focus on fine arts. Housed in a renovated 1950s Basha Grocery Store, the museum contains over 20,000 square feet of exhibition space featuring two temporary exhibit galleries, two classrooms, a gallery shop, and ArtVille, a unique hands-on gallery for children under the age of five. Educational, hands-on, interactive areas augment each temporary exhibition and create memorable and child-friendly museum experiences. In 1987, the Arizona Museum for Youth became a public/private partnership between the City of Mesa and the Arizona Museum for Youth Friends, Inc. The mission of the museum is to design, develop, and present accessible, innovative, and interactive experiences. The vision of the institution is to provide children and families with the best environment to explore, create, and succeed while fostering learning, imagination, creativity, and critical thinking.

ArtVille is a permanent exhibition and activity area at the Arizona Museum for Youth, especially tailored for guests up to five years of age. Visitors enter a small-town environment that familiarizes the family with basic art principles. Several spaces change to match the theme of the art gallery exhibitions.

As the result of a campaign, the birthday of Dr. Martin Luther King was declared a city holiday by the voters in 1996. The holiday honoring the life of the slain civil rights leader was celebrated with a parade, the latest in a calendar of celebrations honoring Mesa's diversity. In 2005, due to the city's increasing budget woes, the annual parade was one of many events no longer funded by the city. A group of citizens and high-school students stepped up and raised the money necessary to continue the parade.

The Mesa Powwow began in the fall of 1984 and has become an annual tradition. The powwow attracts Native Americans from across the country to Mesa to participate in the event.

These Mexican folk dancers are performing a traditional dance at the city's Cinco de Mayo celebration. The community has celebrated this Mexican holiday for many years. Mexican Americans make up a significant percentage of the city's minority population.

BIBLIOGRAPHY

Foster, Keith. *Mesa Heritage Wall: Plaques, Titles, and Text.* Mesa, AZ: Mesa Southwest Museum, 2004.

Jones, Daniel Webster. *Forty Years Among the Indians.* Salt Lake City, UT: Western Lore Press, 1960.

LeSueur, Don L. *Histories of the Descendants of John Taylor LeSueur and William Francis LeSueur.* Mesa, AZ: Self-published, 1990.

Merrill, W. Earl. *One Hundred Steps Down Mesa's Past.* Mesa, AZ: Lofgreen Printing Company, 1970.

Merrill, W. Earl. *One Hundred Yesterdays.* Mesa, AZ: Lofgreen Printing Company, 1972.

Merrill, W. Earl. *One Hundred Echoes From Mesa's Past.* Mesa, AZ: Lofgreen Printing Company, 1975.

Merrill, W. Earl. *One Hundred Footprints on Forgotten Trails.* Mesa, AZ: Lofgreen Printing Company, 1978.

Mesa Chamber of Commerce. *This is Mesa: 1964–1965.* Mesa, AZ: Lane Printing and Publishing, 1965.

Mesa: The Gateway to the Roosevelt Dam. San Francisco, CA: Sunset, The Pacific Monthly, 1915.

Norton, Nancy Dana. *Mezona Memories: A Sentimental Journey.* Mesa, AZ: Legend Express Publishing Company, 2003.

Otis, Reta Reed. *Mesa at War.* Mesa, AZ: Mesa Historical Society, 1996

Rogers, Mona. *Rogers Roots, Branches and Twigs.* Mesa, AZ: Cox Printing, 1998.

Smith, Jared A. *Making Water Flow Uphill: The History of Agriculture in Mesa, Az.* Mesa, AZ: Mesa Historical Society, 2004.

ACROSS AMERICA, PEOPLE ARE DISCOVERING SOMETHING WONDERFUL. THEIR HERITAGE.

Arcadia Publishing is the leading local history publisher in the United States. With more than 4,000 titles in print and hundreds of new titles released every year, Arcadia has extensive specialized experience chronicling the history of communities and celebrating America's hidden stories, bringing to life the people, places, and events from the past. To discover the history of other communities across the nation, please visit:

www.arcadiapublishing.com

Customized search tools allow you to find regional history books about the town where you grew up, the cities where your friends and family live, the town where your parents met, or even that retirement spot you've been dreaming about.